D1571682

BROKEN DREAM

DREAM

20 Years of War in Eastern Europe

ANTONIN **KRATOCHVIL**

THE MONACELLI PRESS

First published in the United States of America in 1997 by
The Monacelli Press, Inc.
10 East 92nd Street, New York, New York 10128.

Library of Congress Cataloging-in-Publication Data
Kratochvil, Antonin, date.
Broken dream : 20 years of war in Eastern Europe /
Antonin Kratochvil.
p. cm.
ISBN 1-885254-78-4
1. Documentary photography—Europe, Eastern.
2. Europe, Eastern—History—1945–1989—Pictorial works.
3. Europe, Eastern—History—1989– —Pictorial works.
4. Europe, Eastern—Social life and customs—Pictorial works.
I. Title.
TR820.5.K73 1997
779'.9947085—dc21 97-26500

Printed and bound in Italy

to Gábi & Wayne

INTRODUCTION

I began photographing the Communist countries of the old Eastern Europe in 1976. I was born and grew up in Czechoslovakia, so that world was home for me—but it was also the kind of home that I had run away from.

I was both drawn to and repelled by this rough region of Europe. I was drawn to it because it held my memories. I knew it well and the West did not. Back then there were few journalists working in that corner of the world because no one wanted to put up with all the hassles of everyday life there, the petty bribes, the rules, the stamps, the pointless paperwork, and so on. Taking pictures was always an adventure: in the old Eastern Europe, a photographer or journalist was automatically assumed to be a spy. I was arrested more than twenty times while working in Romania, Poland, and Czechoslovakia, though I never lost a single roll of film.

I was repelled by the sleazy reality of the totalitarian countries: politicians were shameless. There were corruption, pollution, shoddy goods, long lines, and suicide everywhere, but the leaders kept boasting about their great achievements and bright tomorrows. I saw all this and tried to show it in my pictures as simply and straightforwardly as I could. All I wanted to do was record how all those poor people adapted to lies and suffering, how they got used to it, how in fact they were bound to miss it when it was over.

Stalin said that artists are the engineers of human souls. I wanted to show what happens to the soul when the engineers get through with it.

BROKEN DREAM

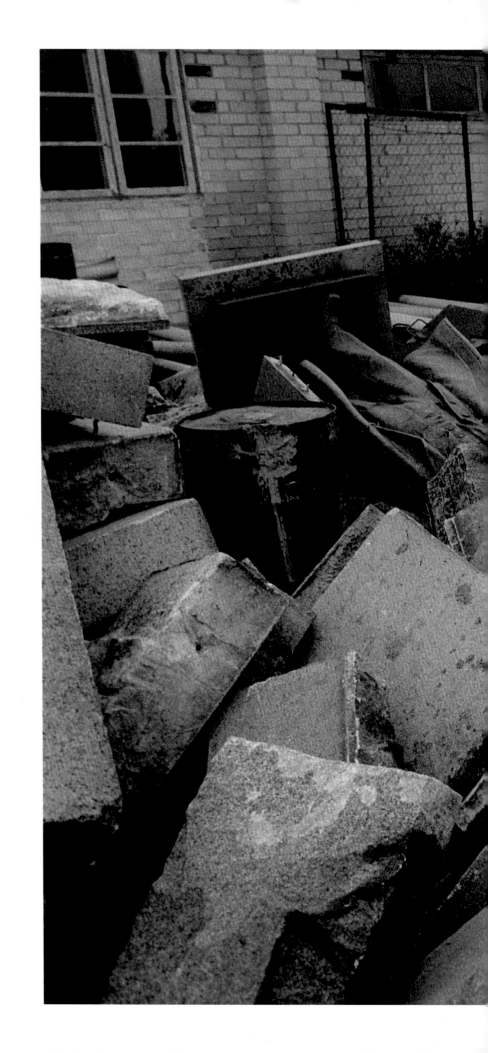

Lenin in a Dump, Estonia 1990

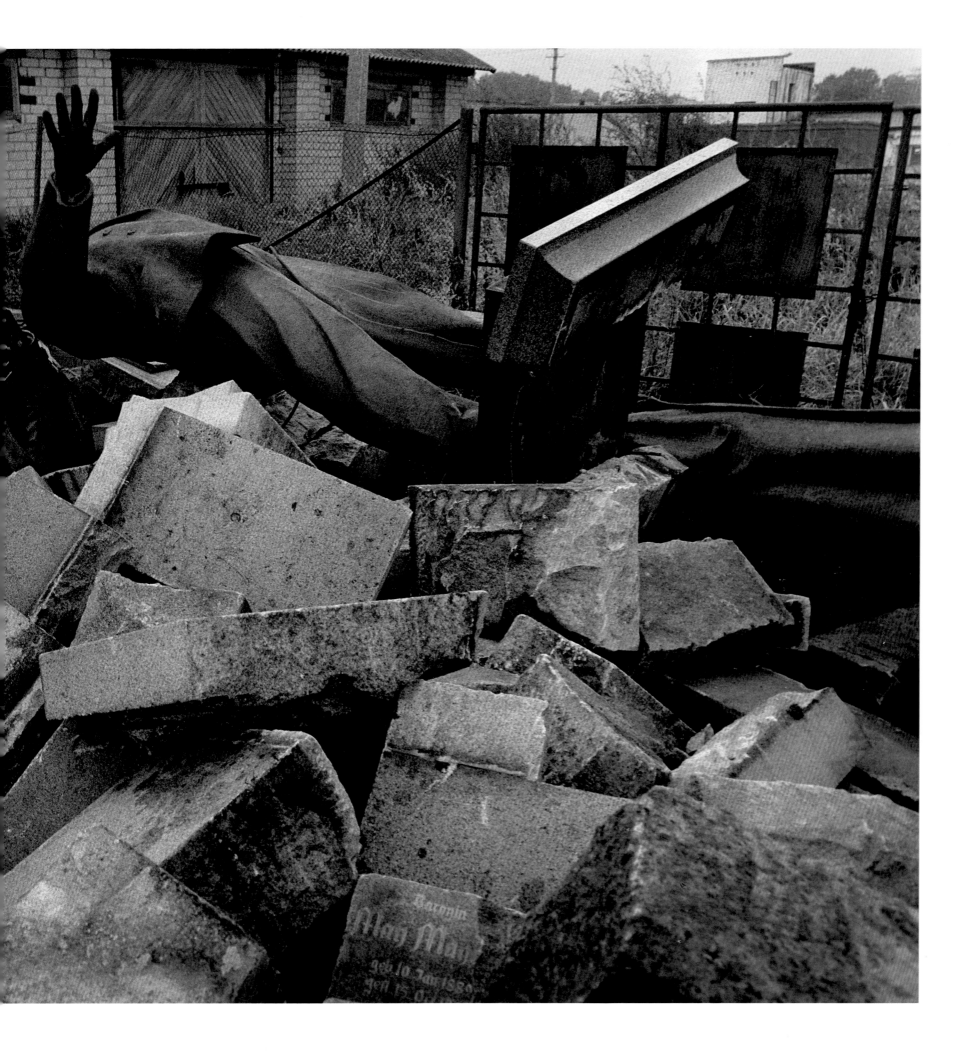

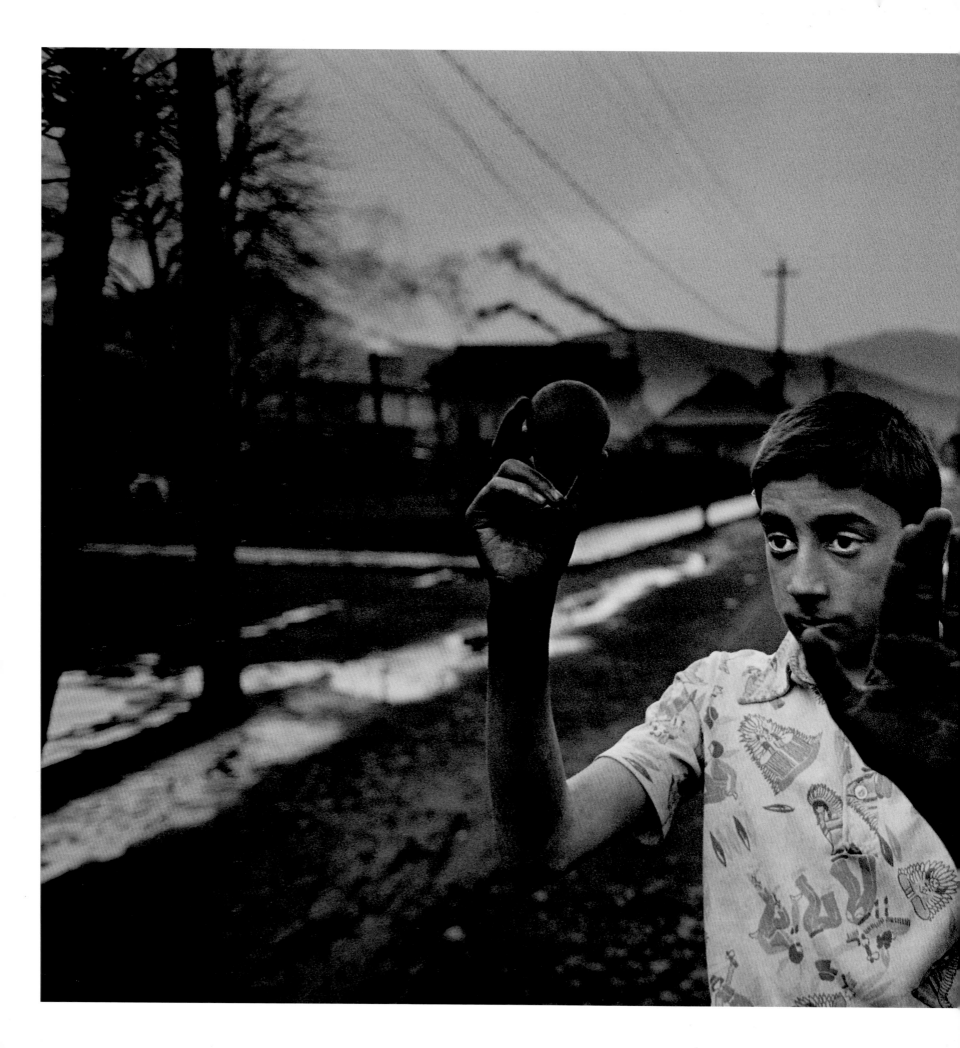

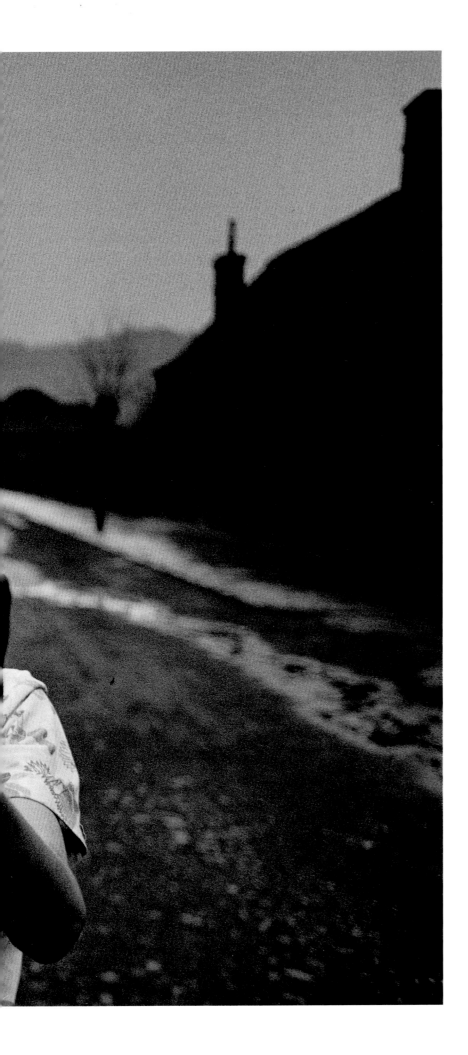

Polluted Playground, Romania 1990

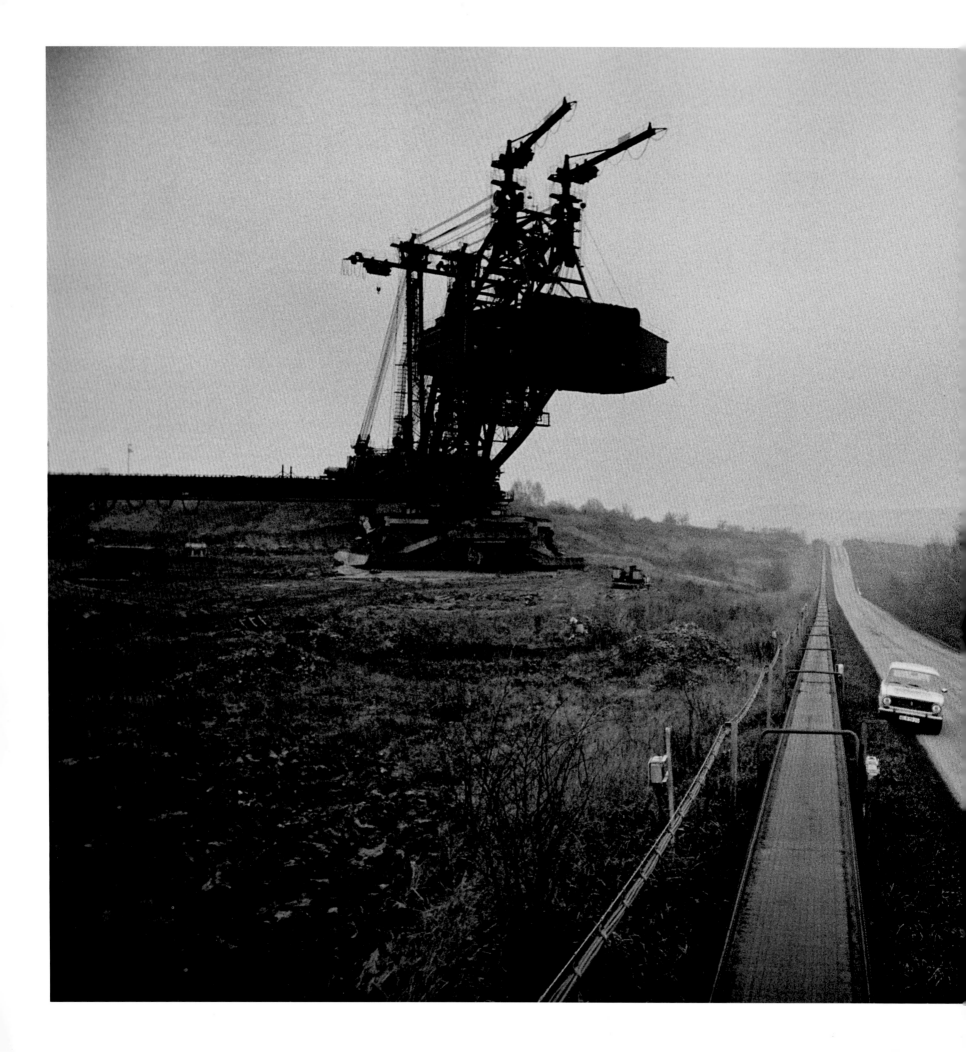

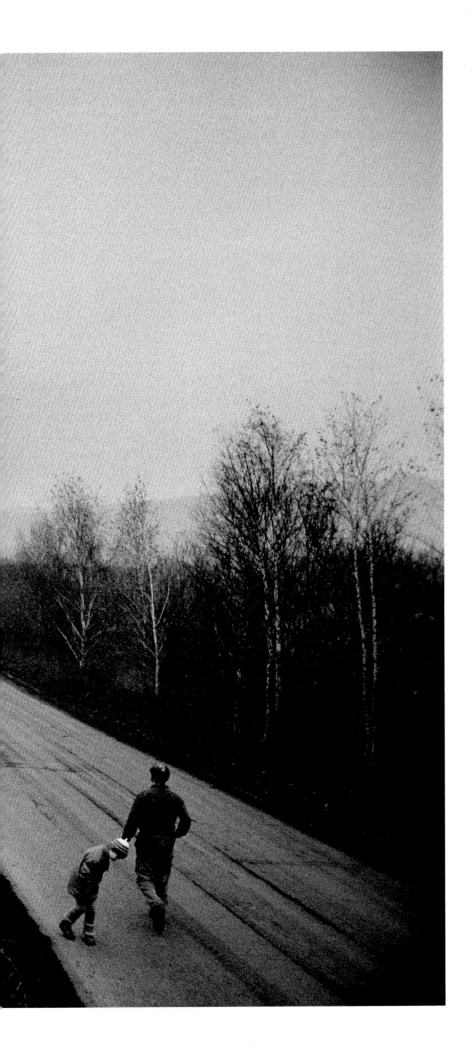

Earth Eater, Czech Republic 1995

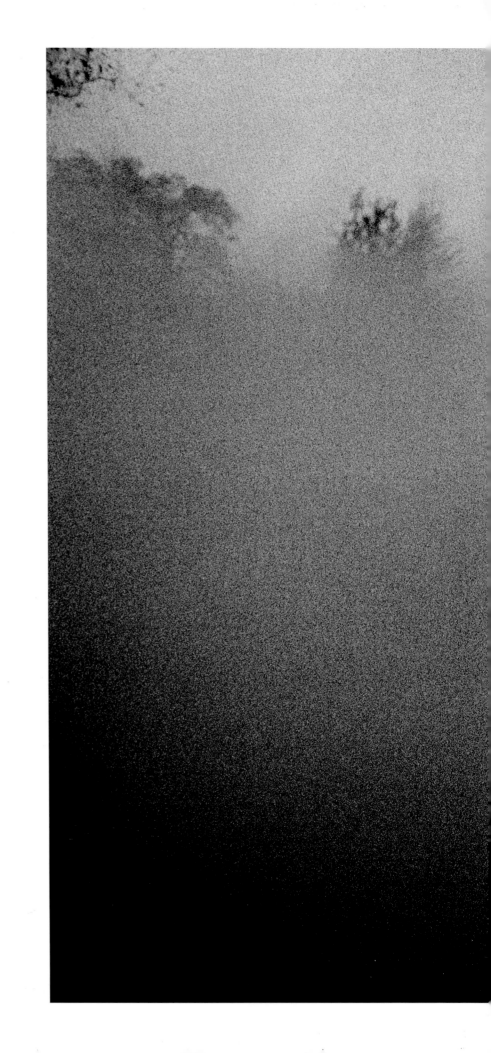

Industrial Town, Czech Republic 1995

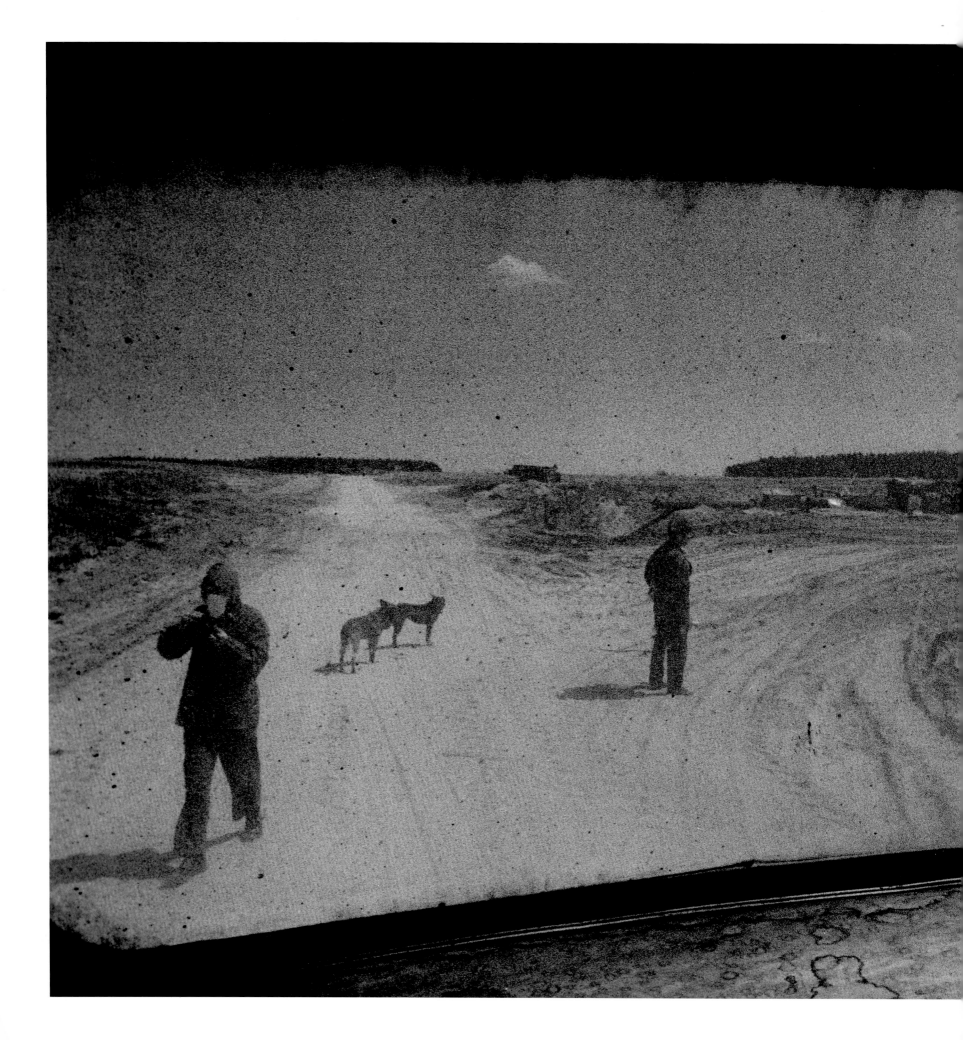

Radioactive Cemetery at Chernobyl, Ukraine 1996

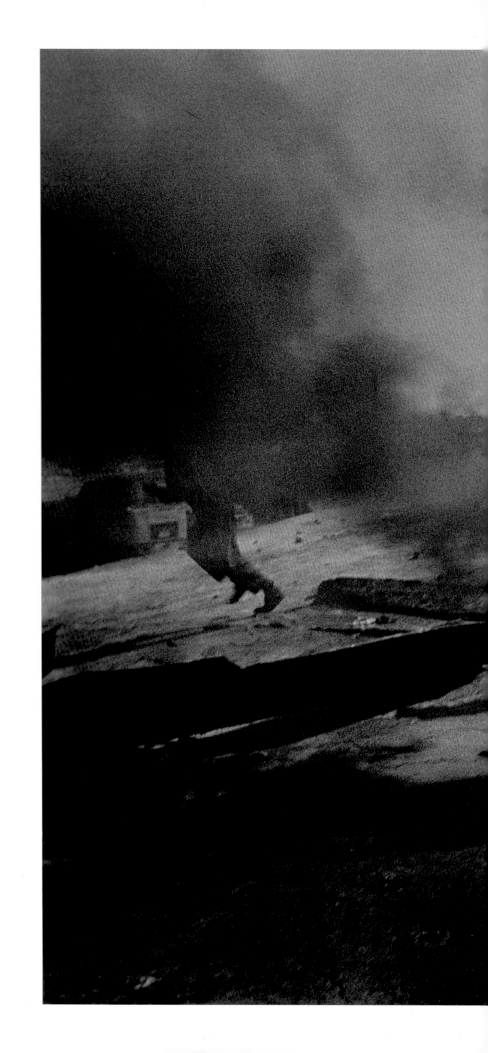

Tar Factory, Romania 1978

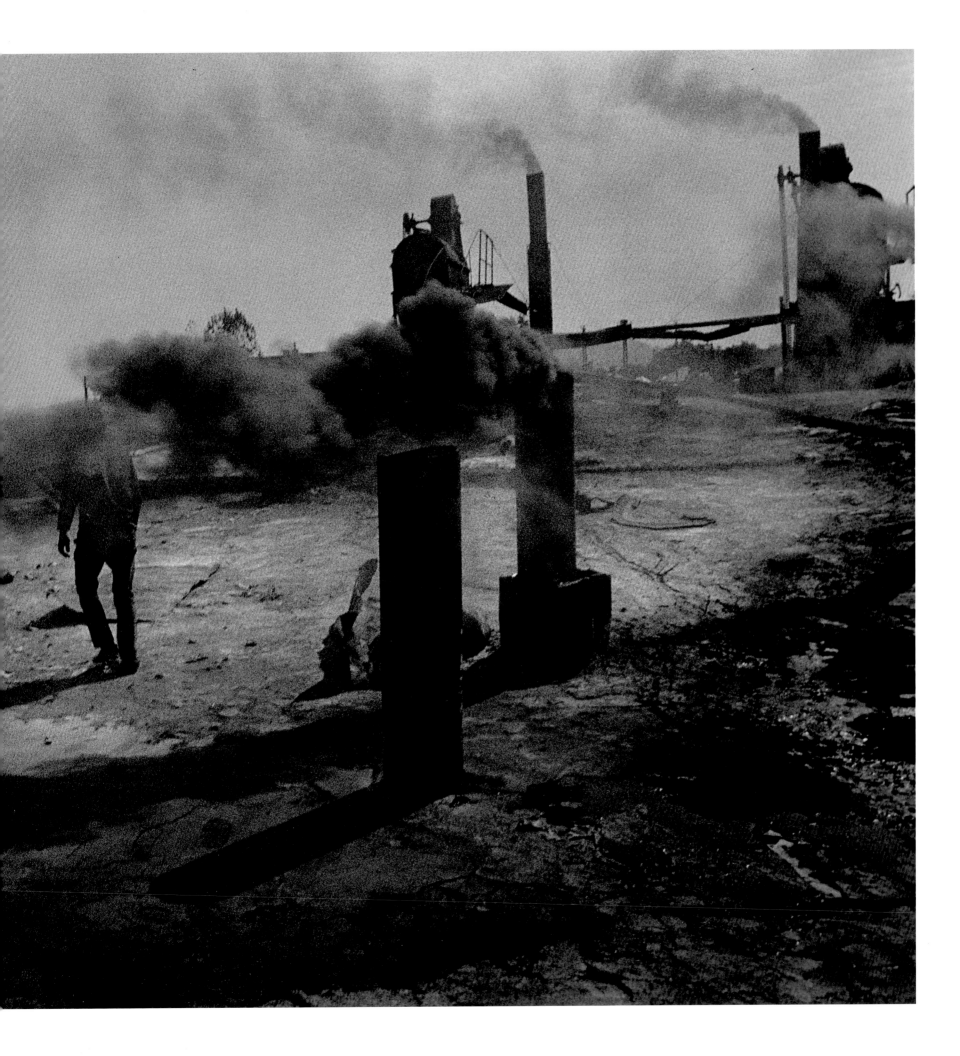

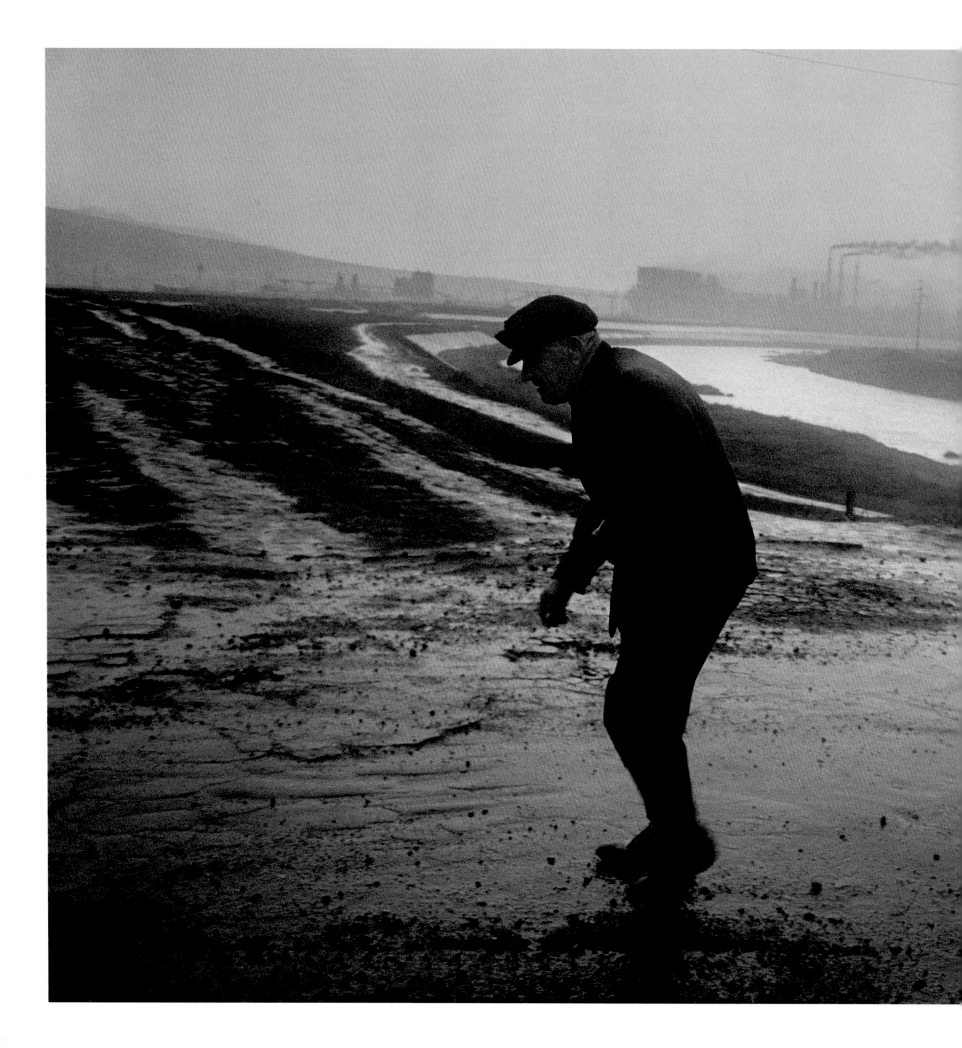

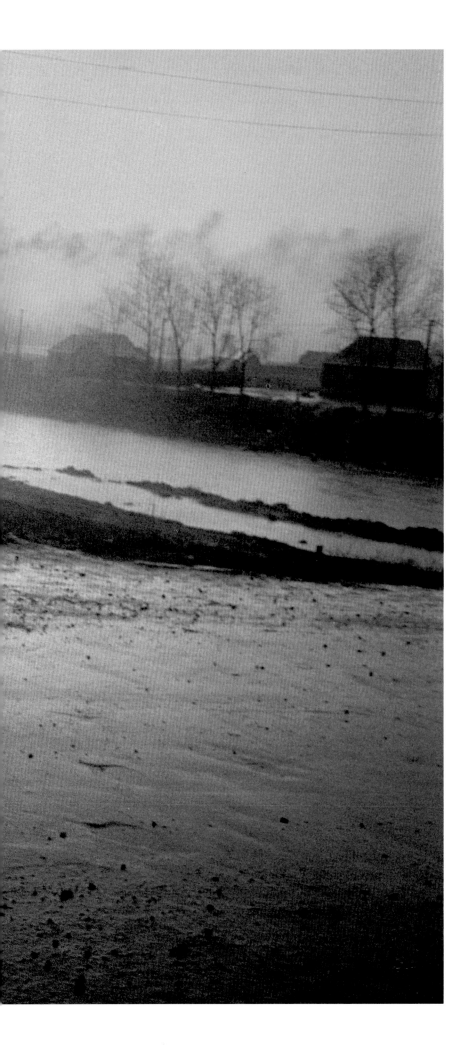

Industrial Landscape, Romania 1990

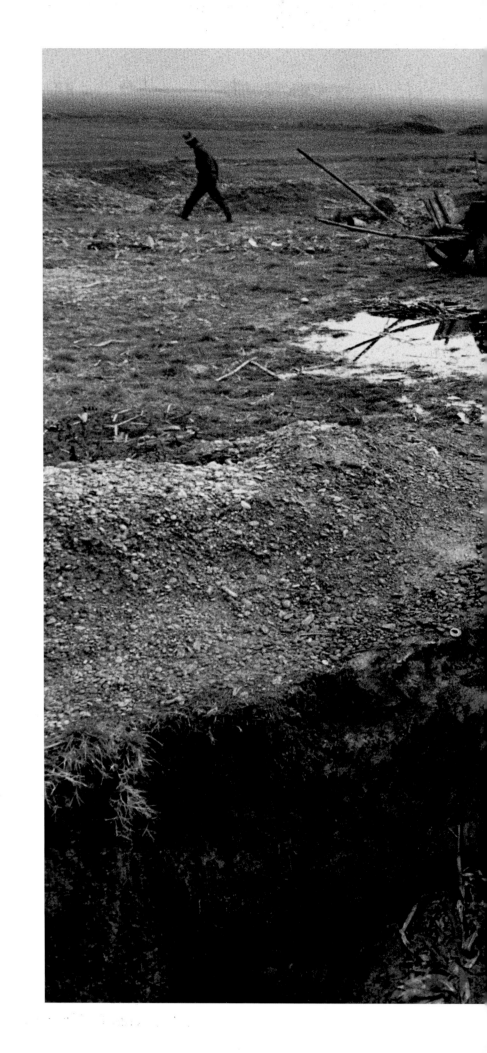

Gazari (Gasoline People), Romania 1995

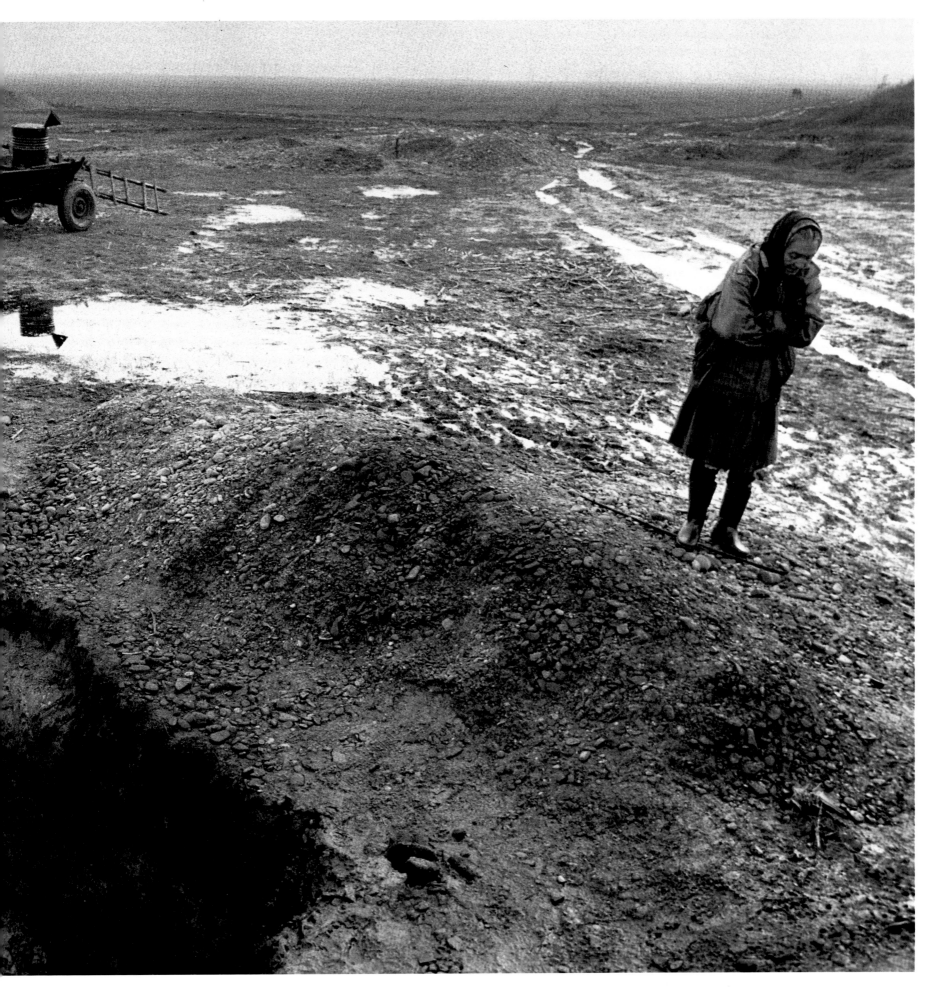

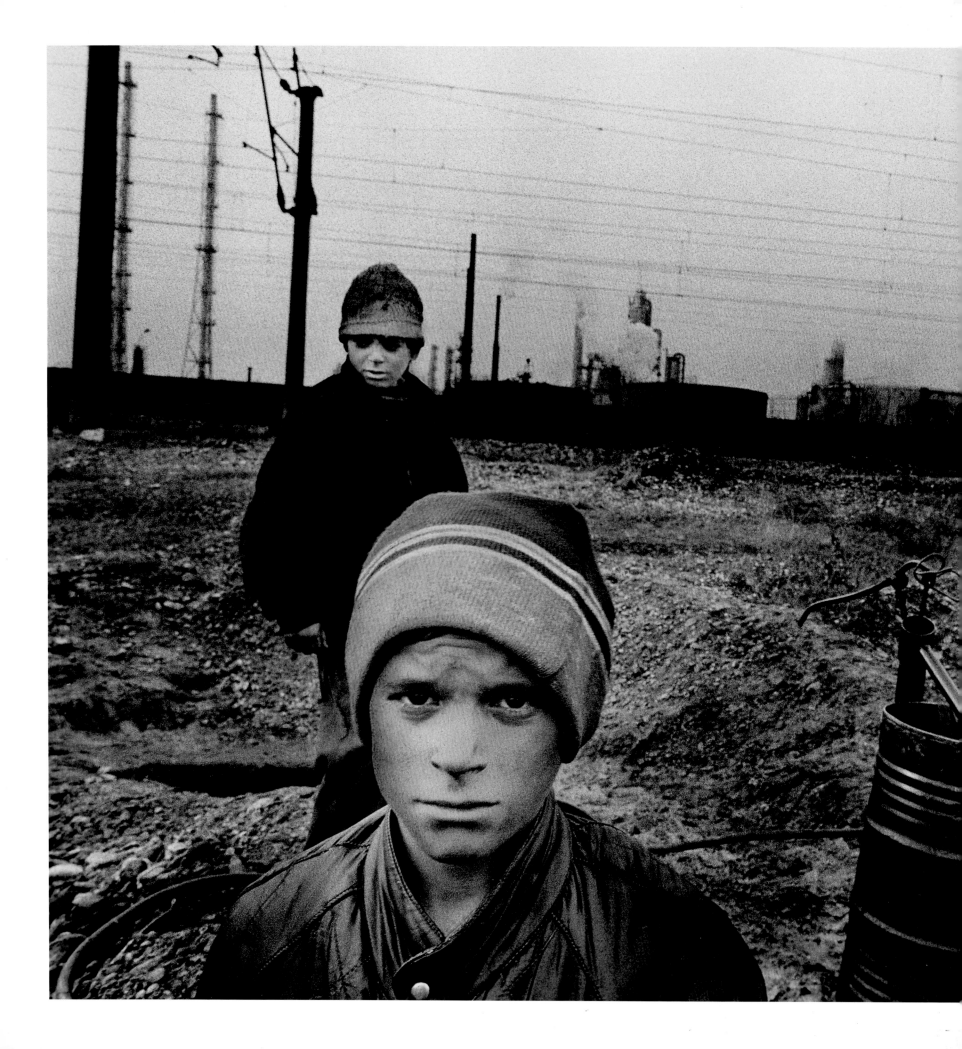

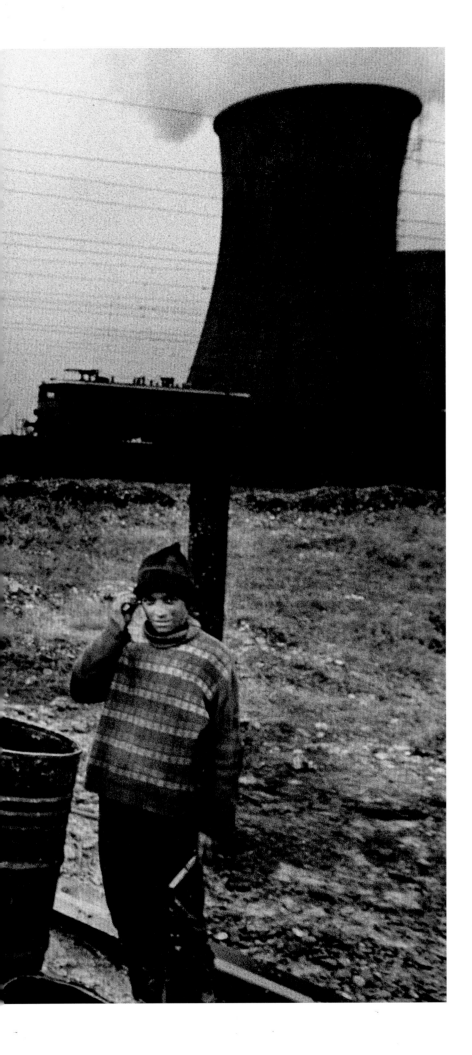

Gazari, Romania 1995

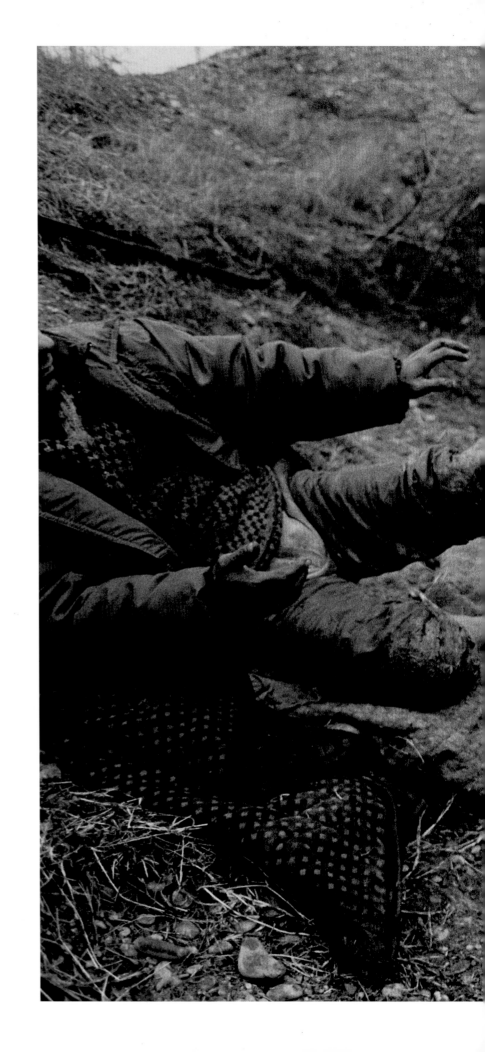

Gazari, Romania 1995

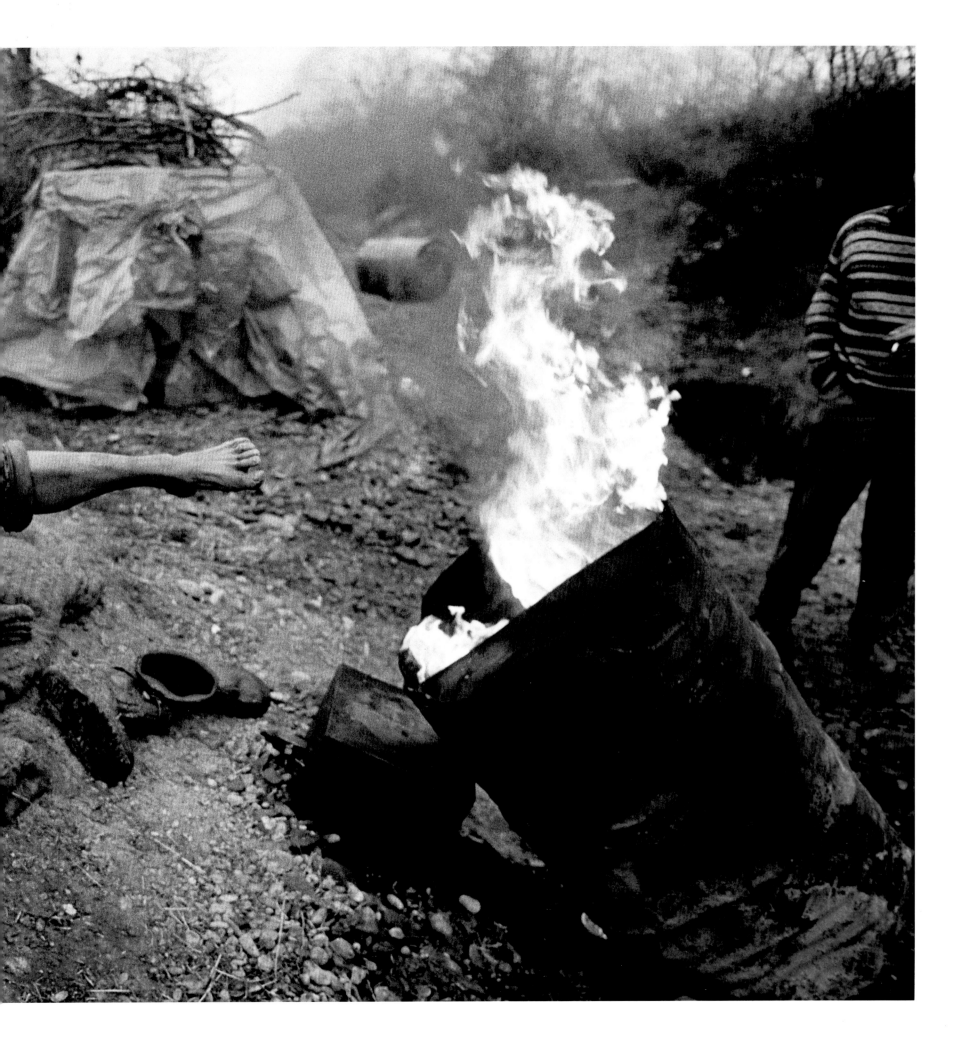

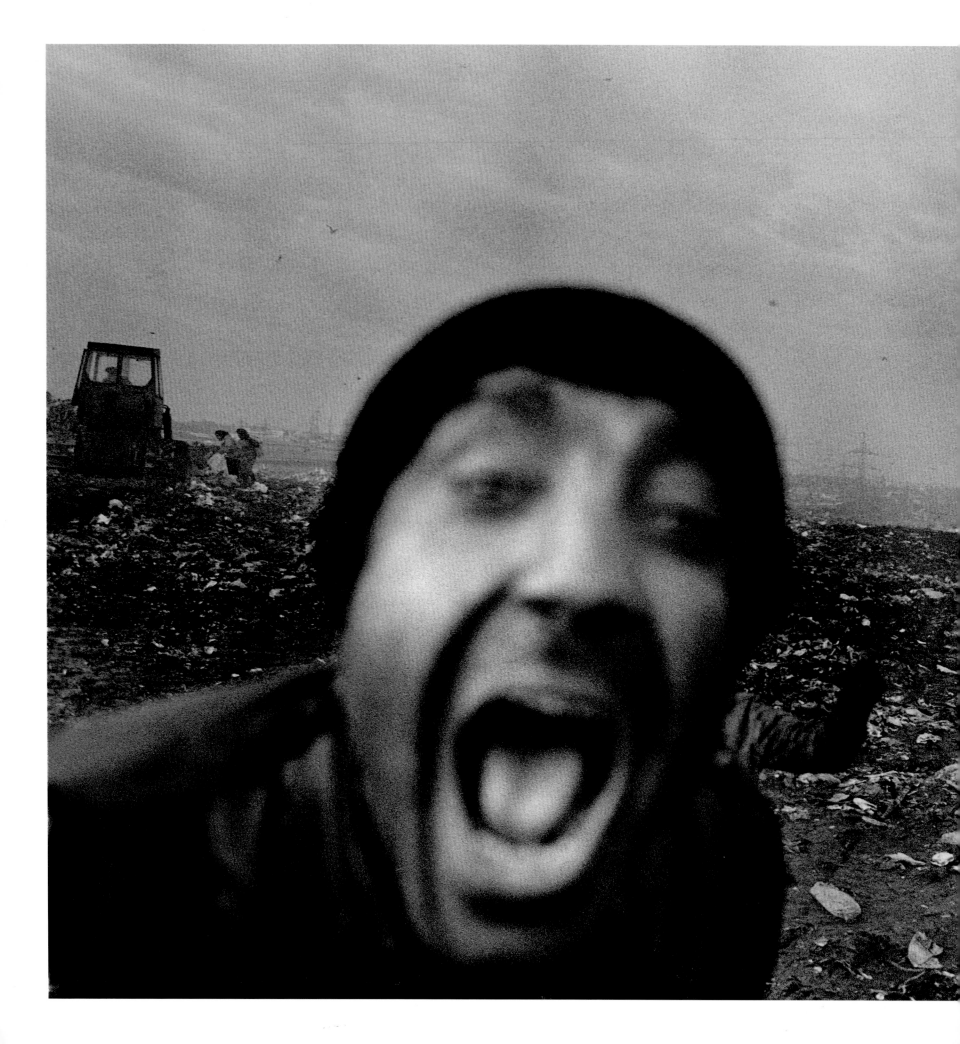

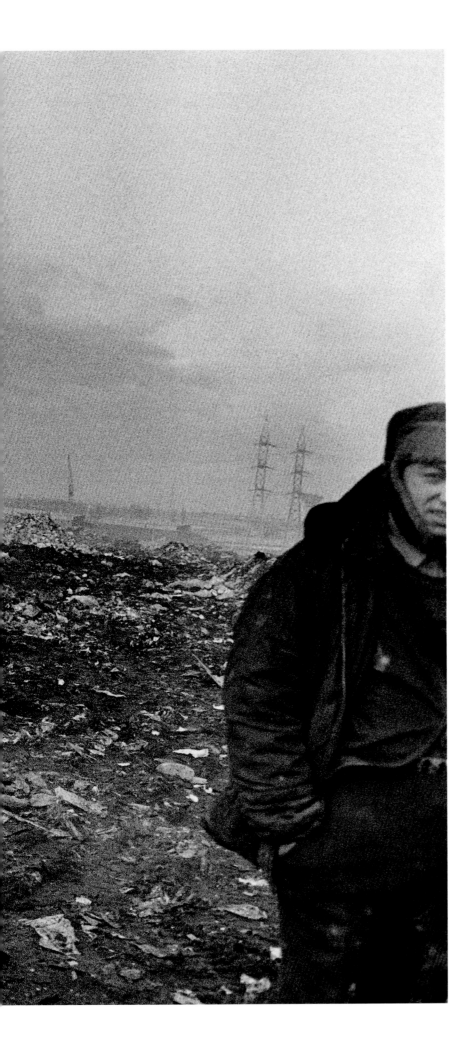

Scream, Romania 1995

Polluted Garden, Romania 1995

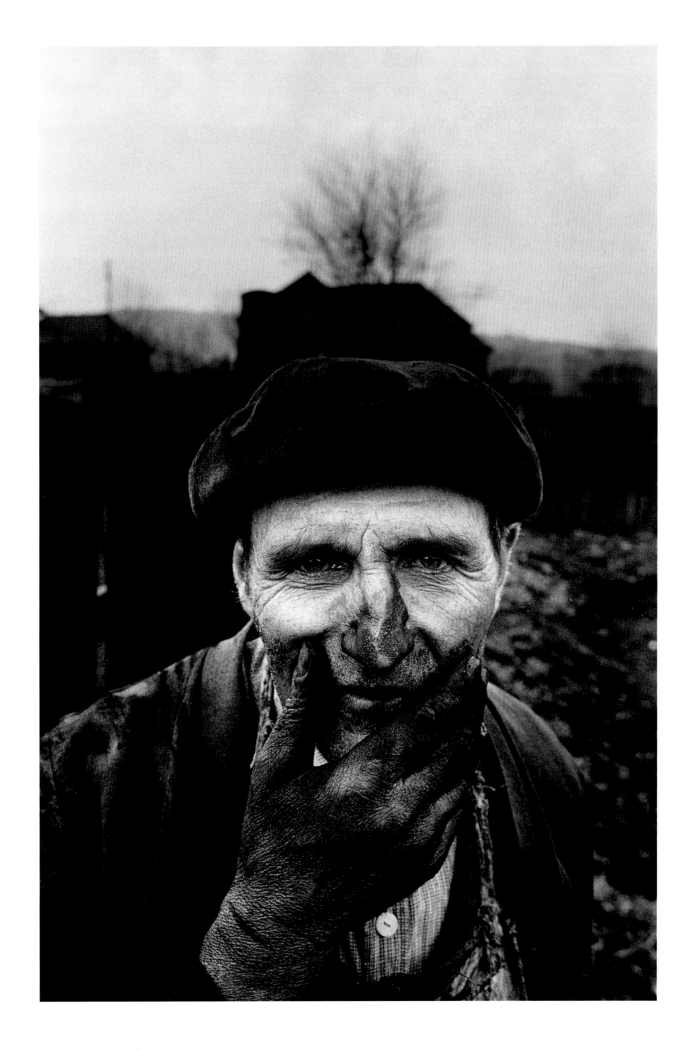

Religious Gathering, Eastern Poland 1978

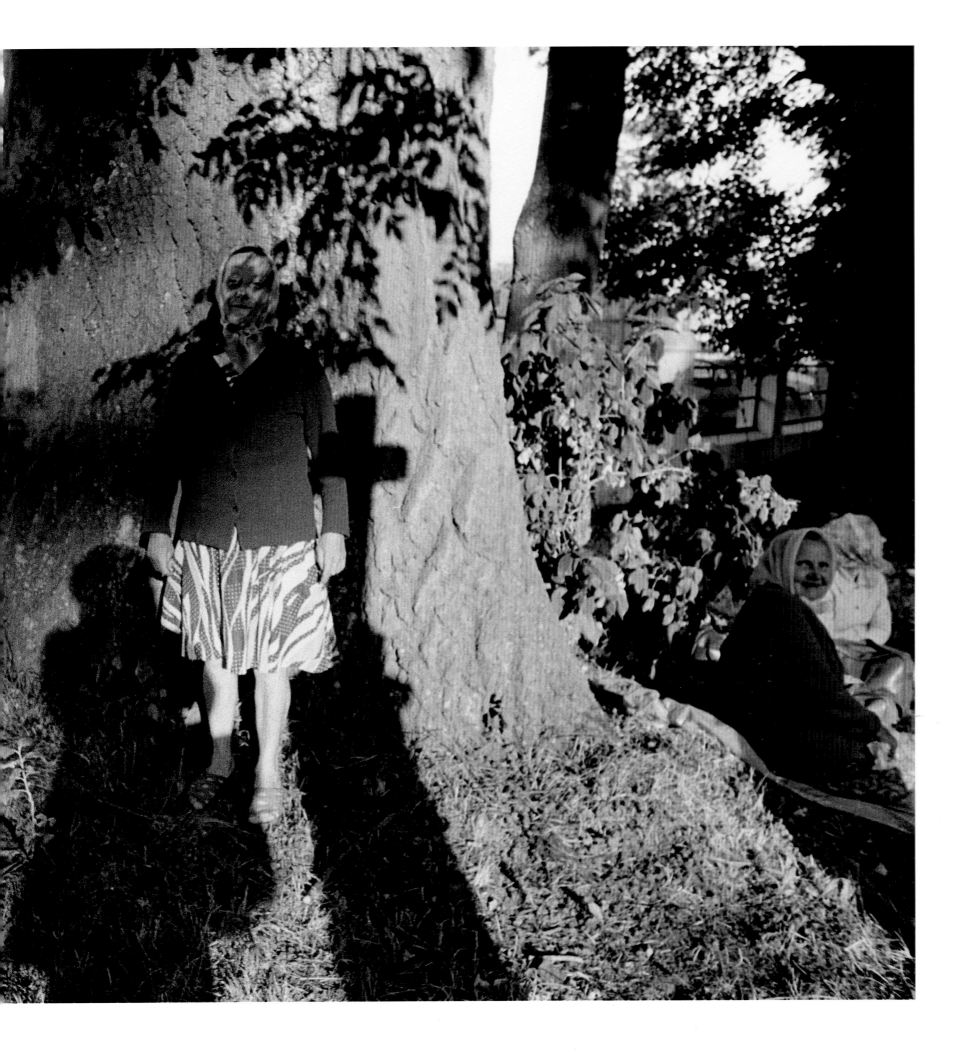

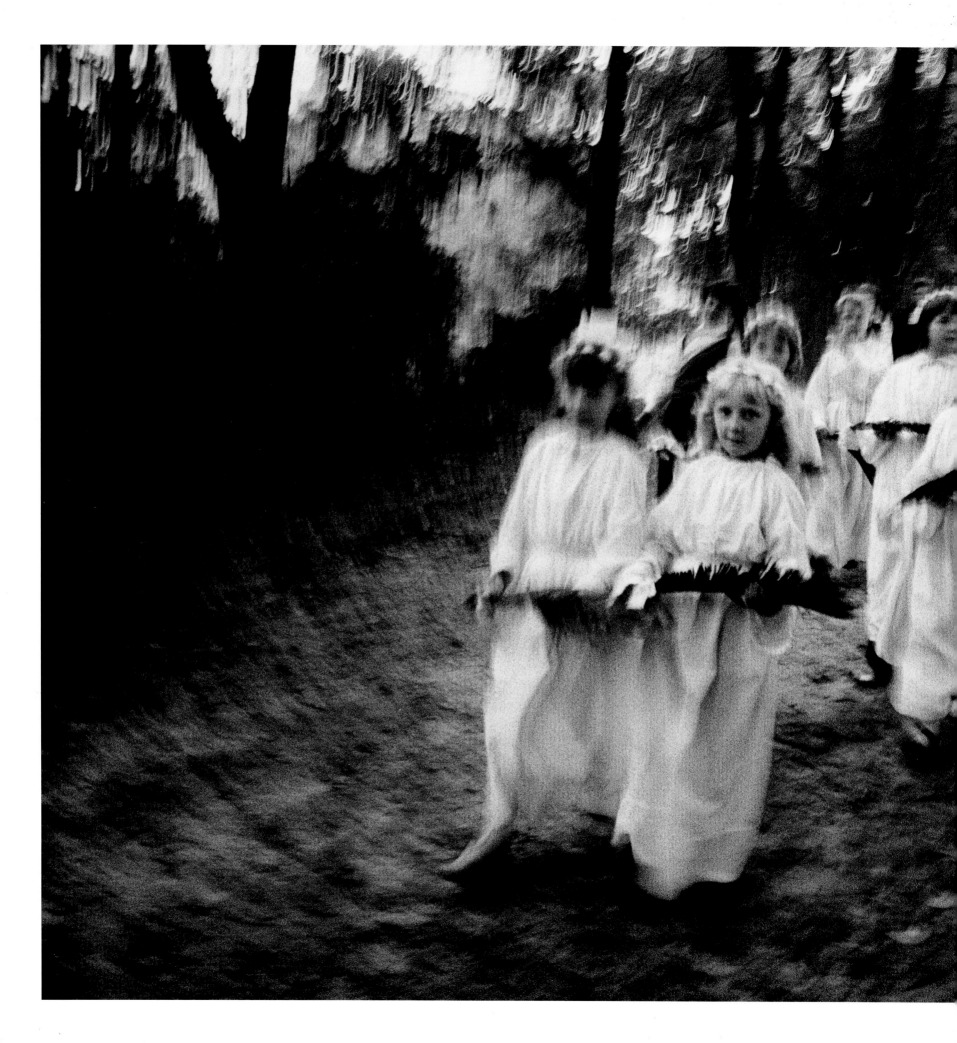

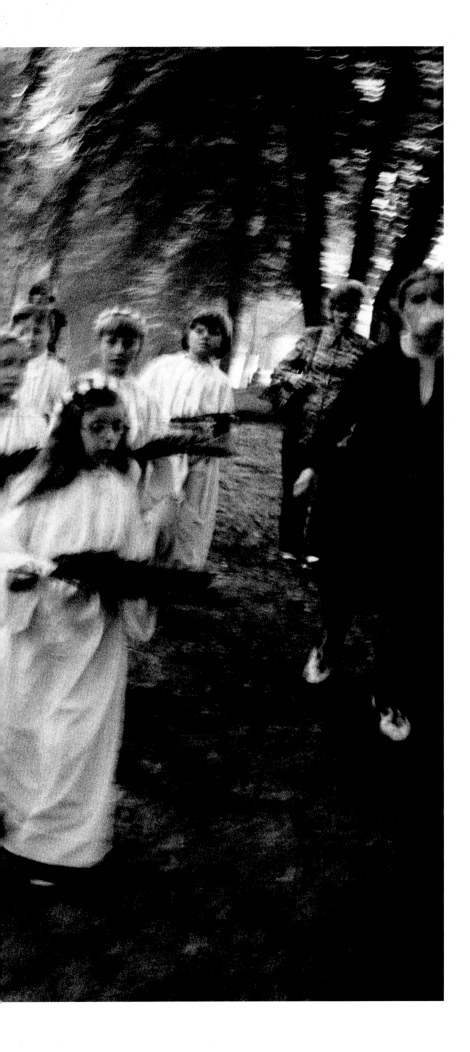

Palm Sunday, Poland 1978

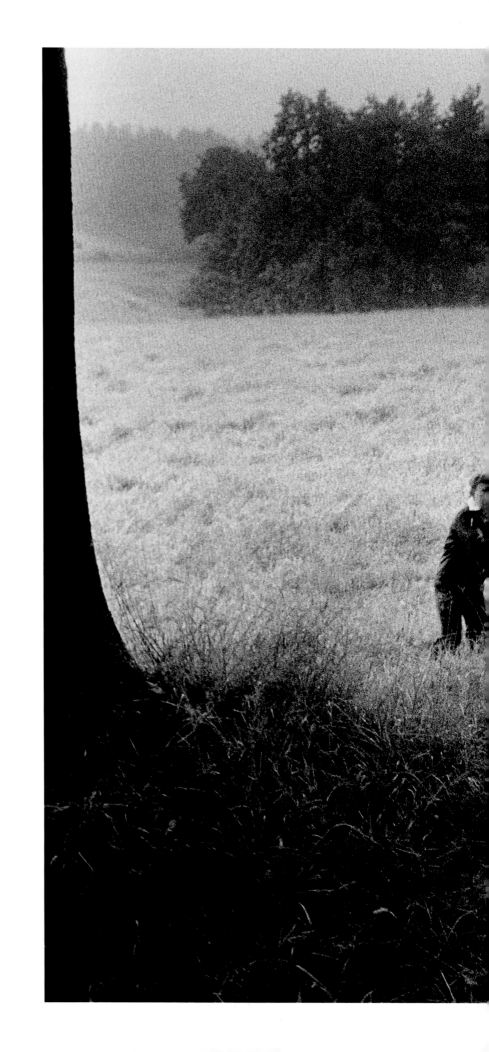

Procession of the Virgins, Poland 1978

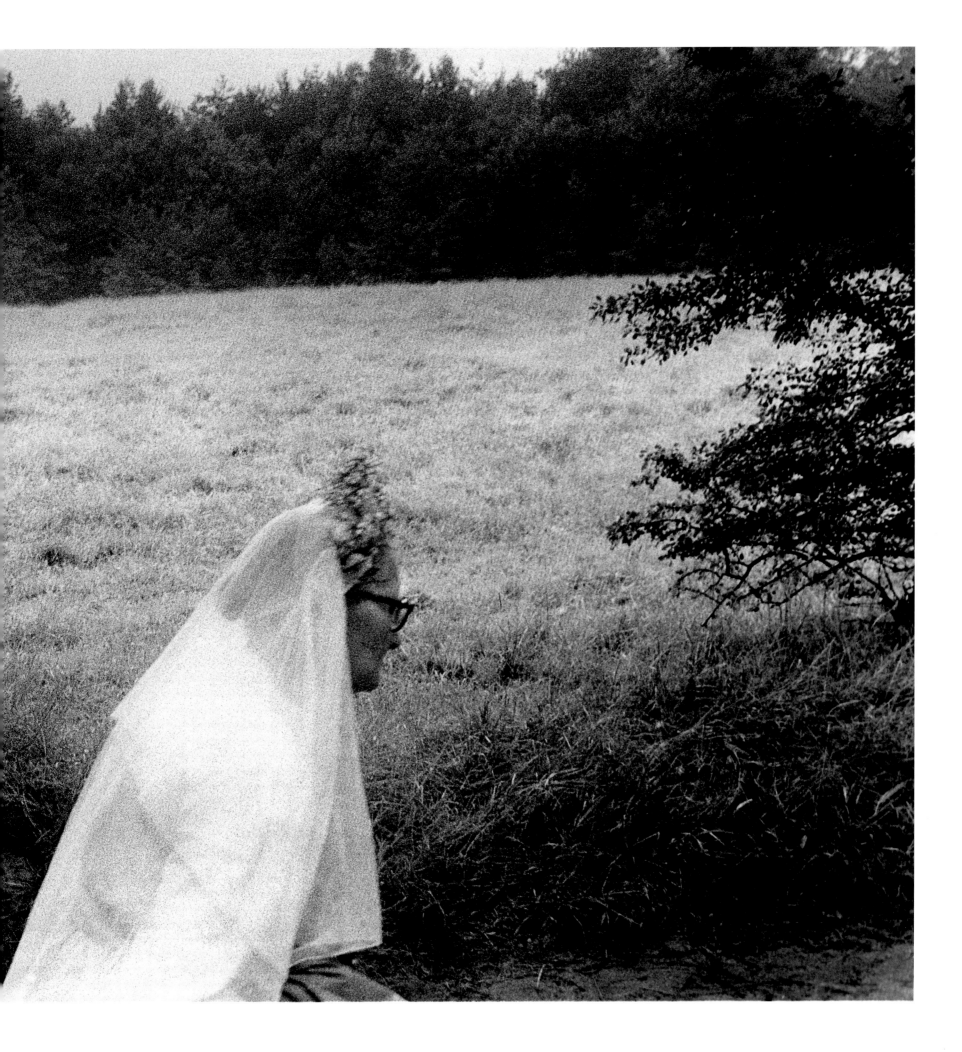

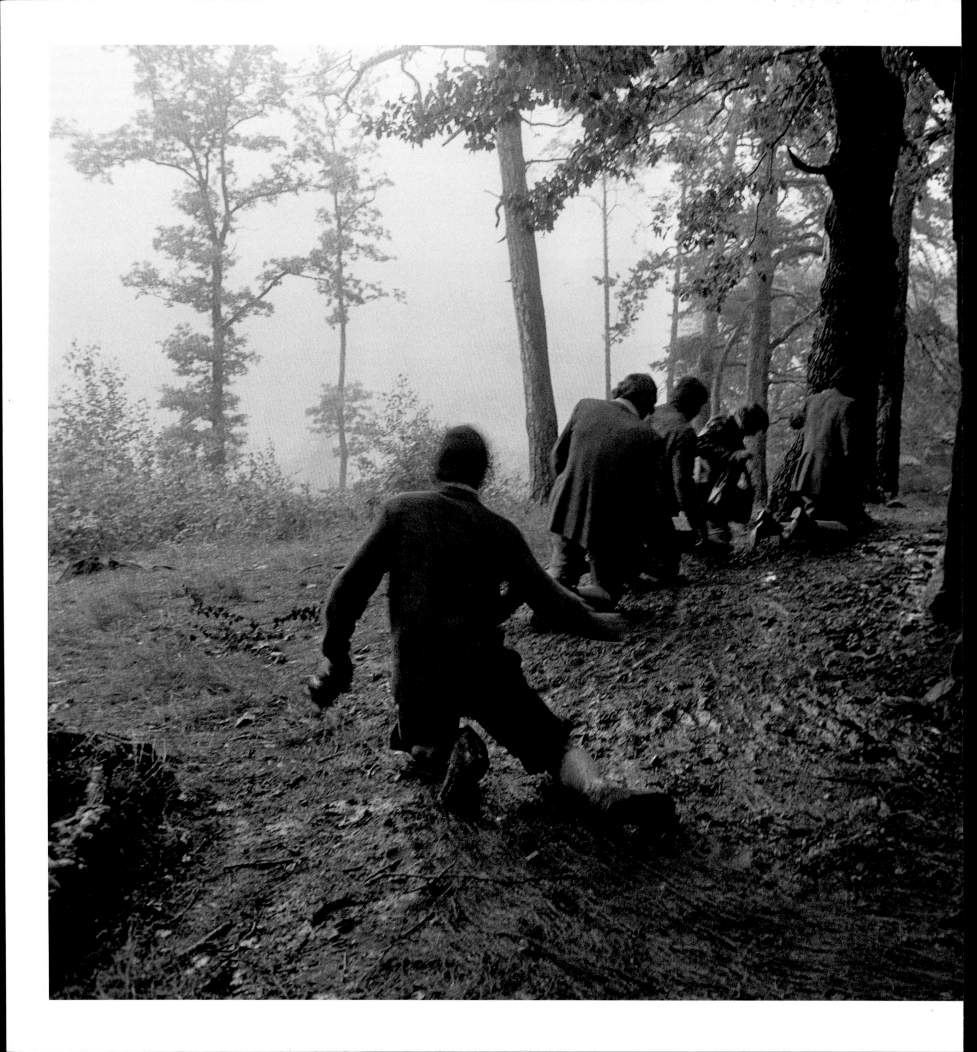

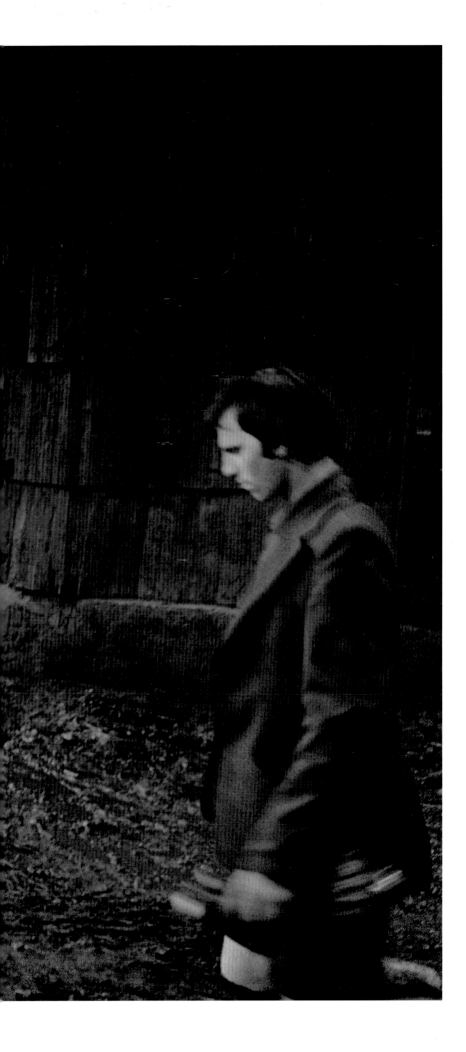

Penance, Poland 1976

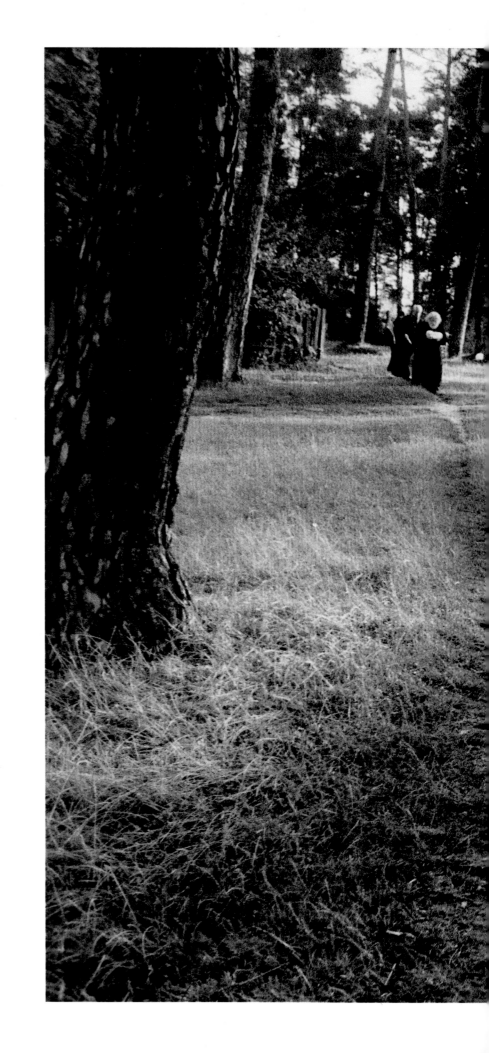

Orthodox Convent, Poland 1978

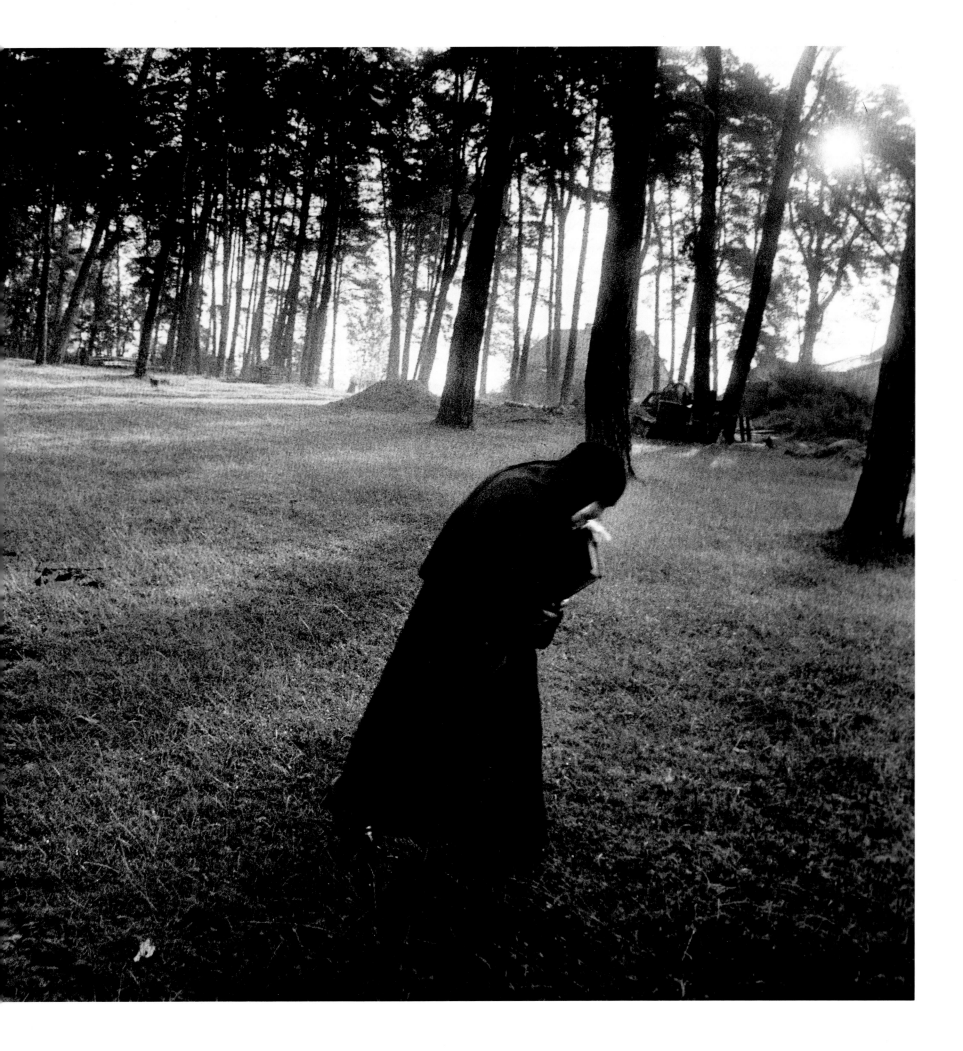

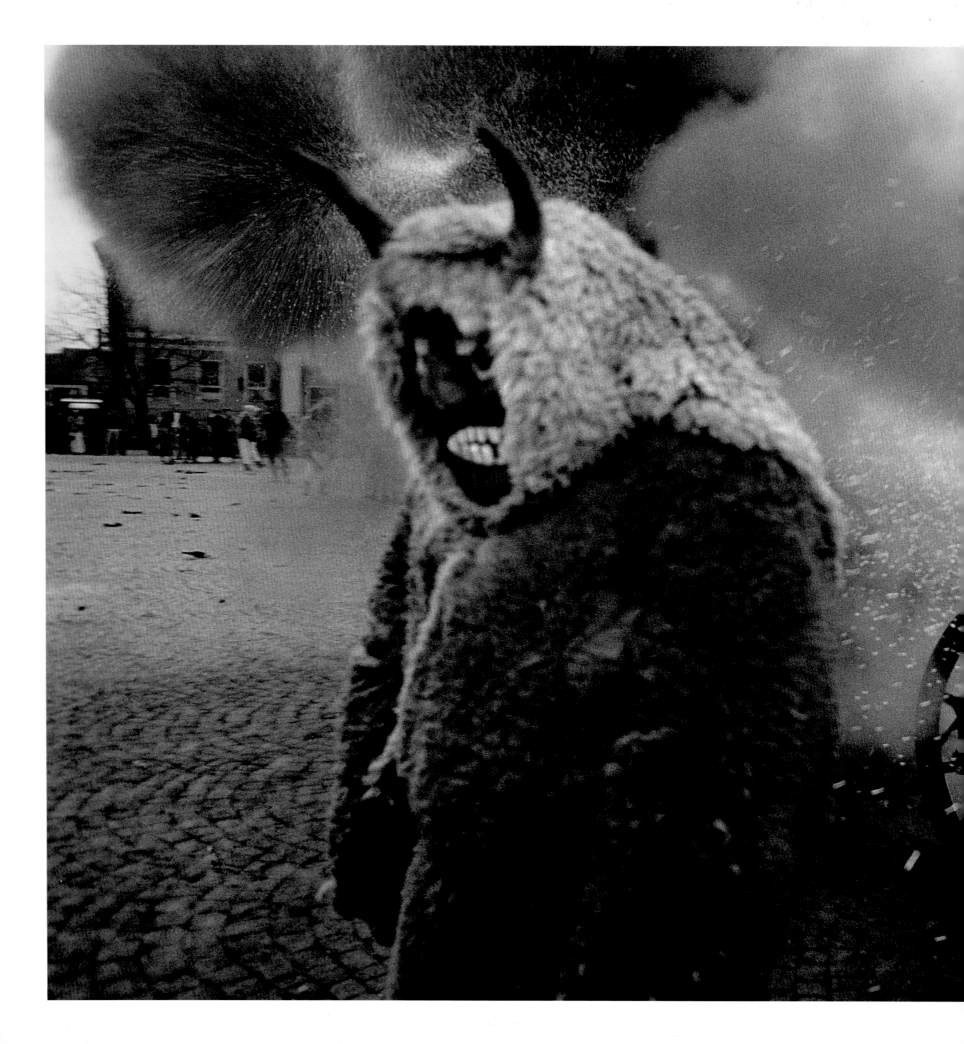

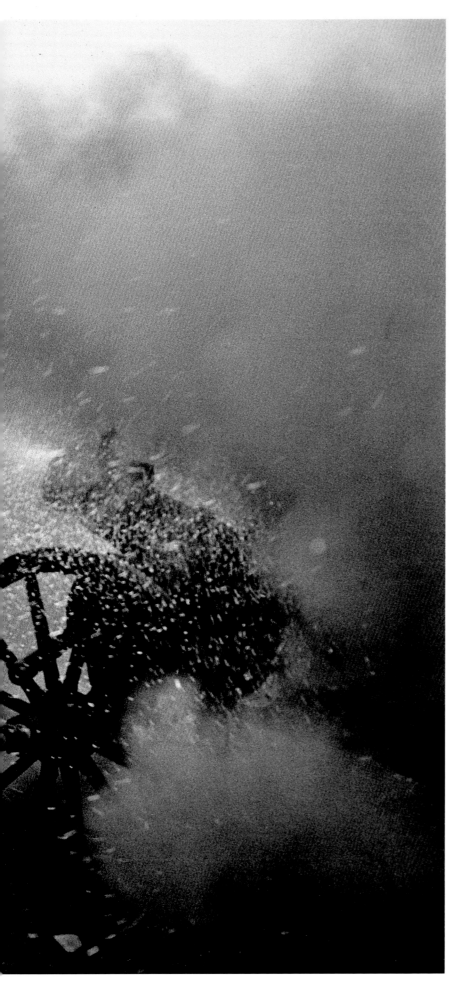

Pagan Festival, Hungary 1992

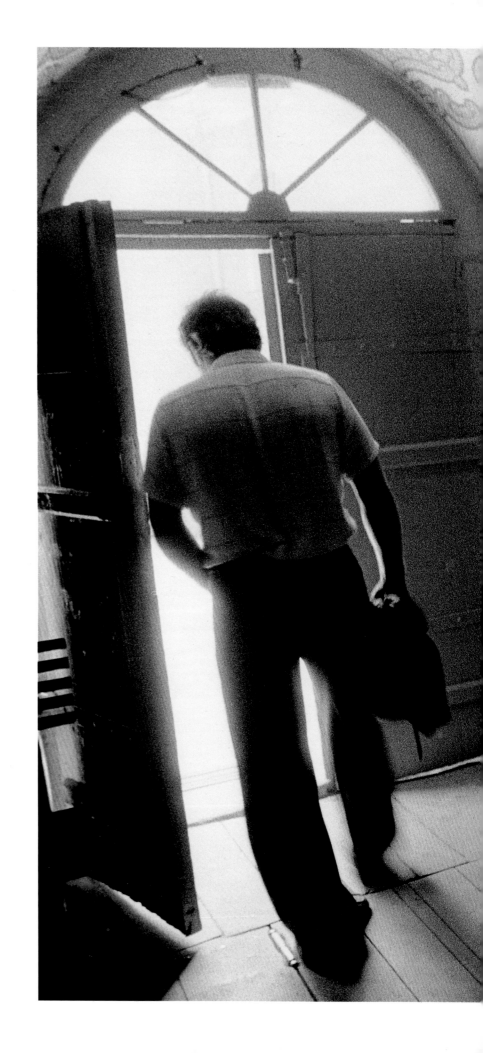

Chapel of the Skulls, Poland 1978

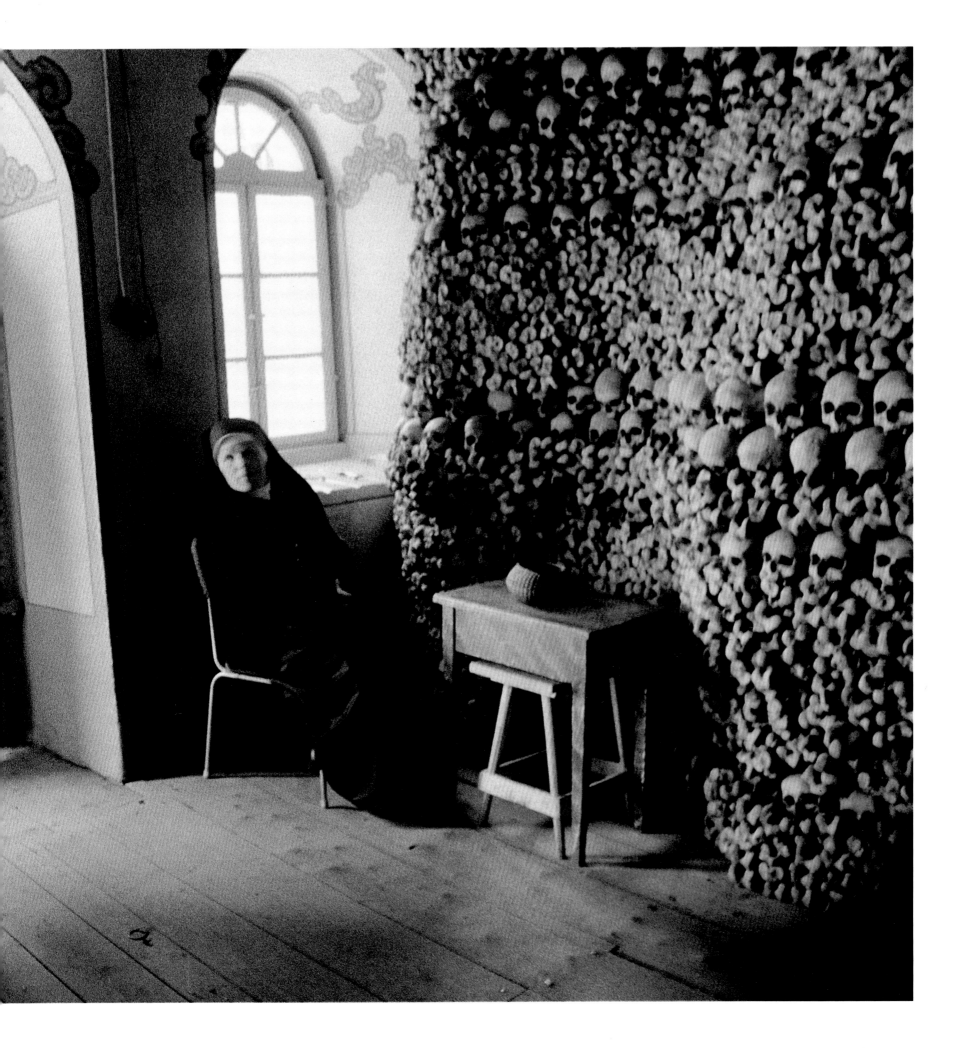

Pilgrims, Poland 1977

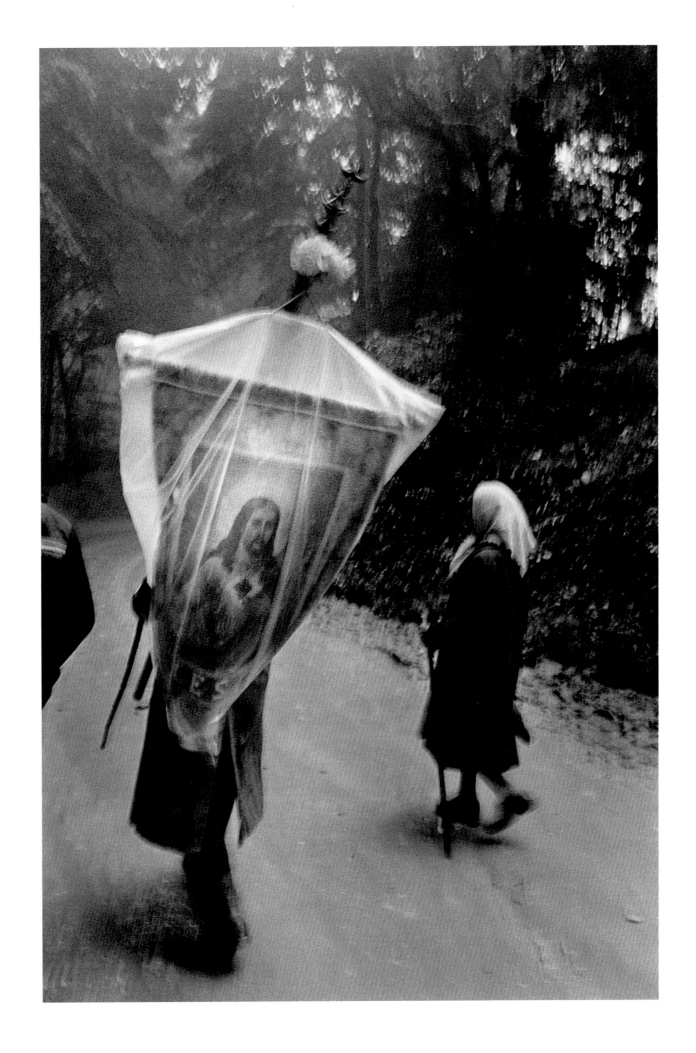

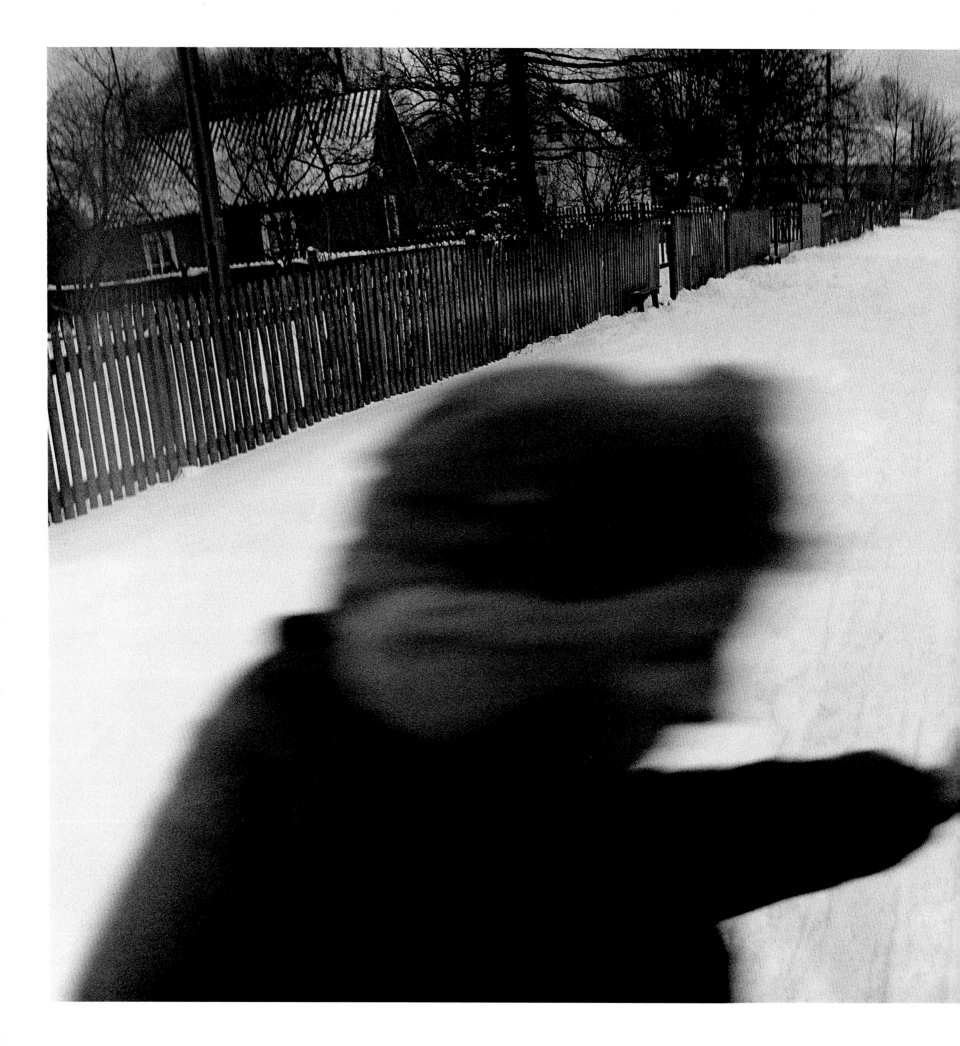

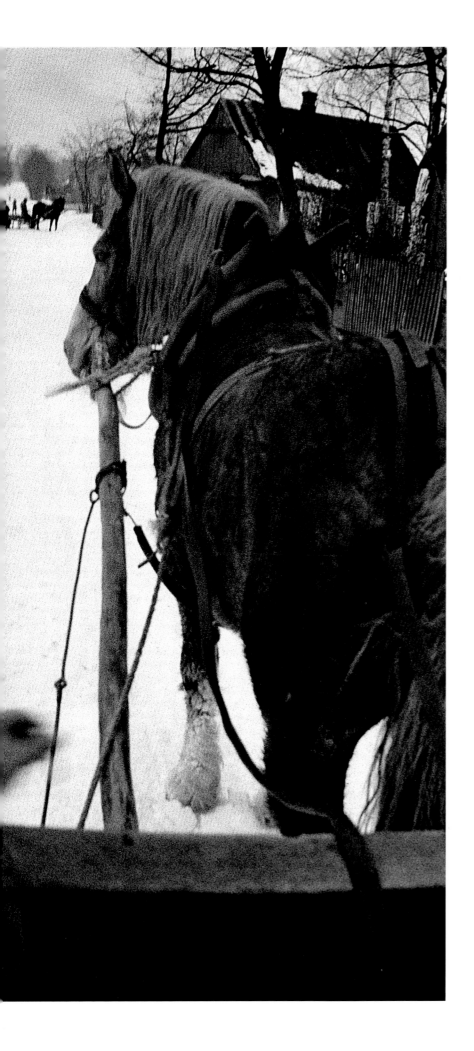

Village, Poland 1990

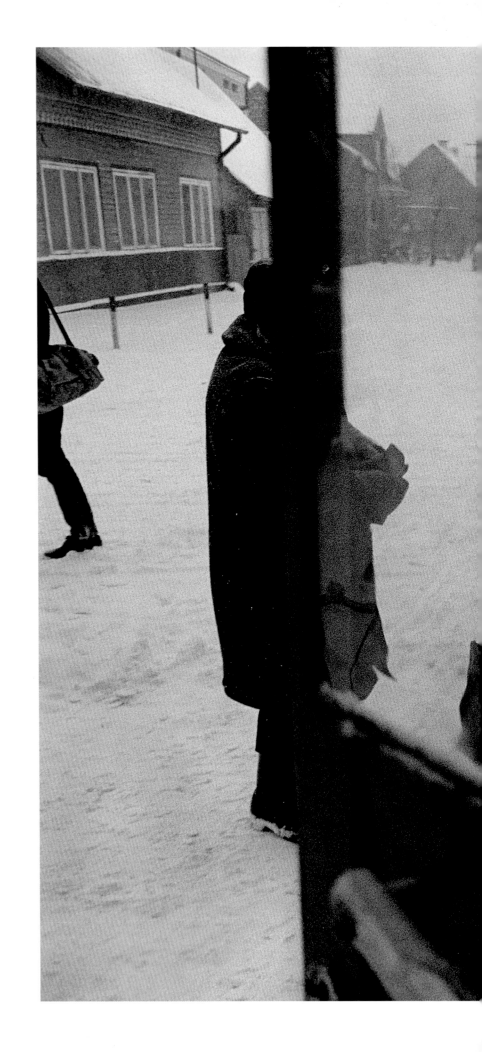

Snowbound, Poland 1990

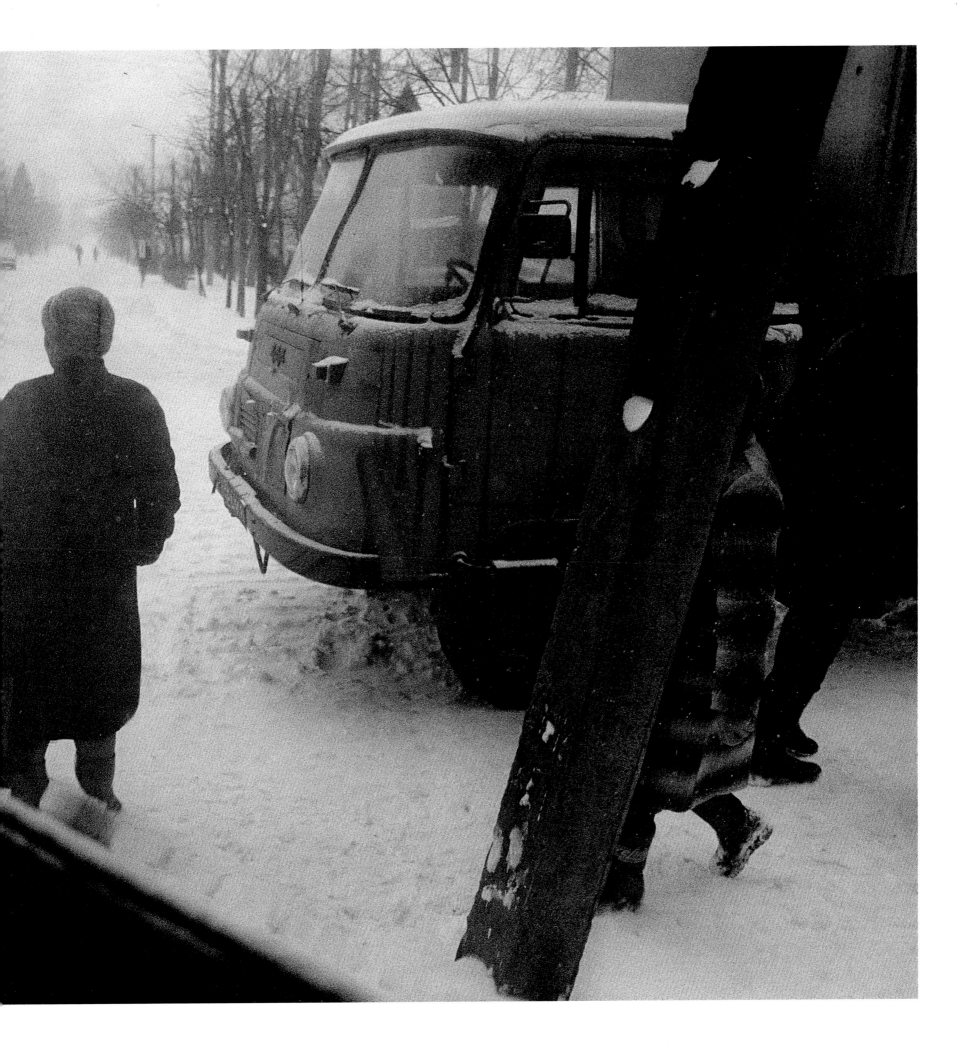

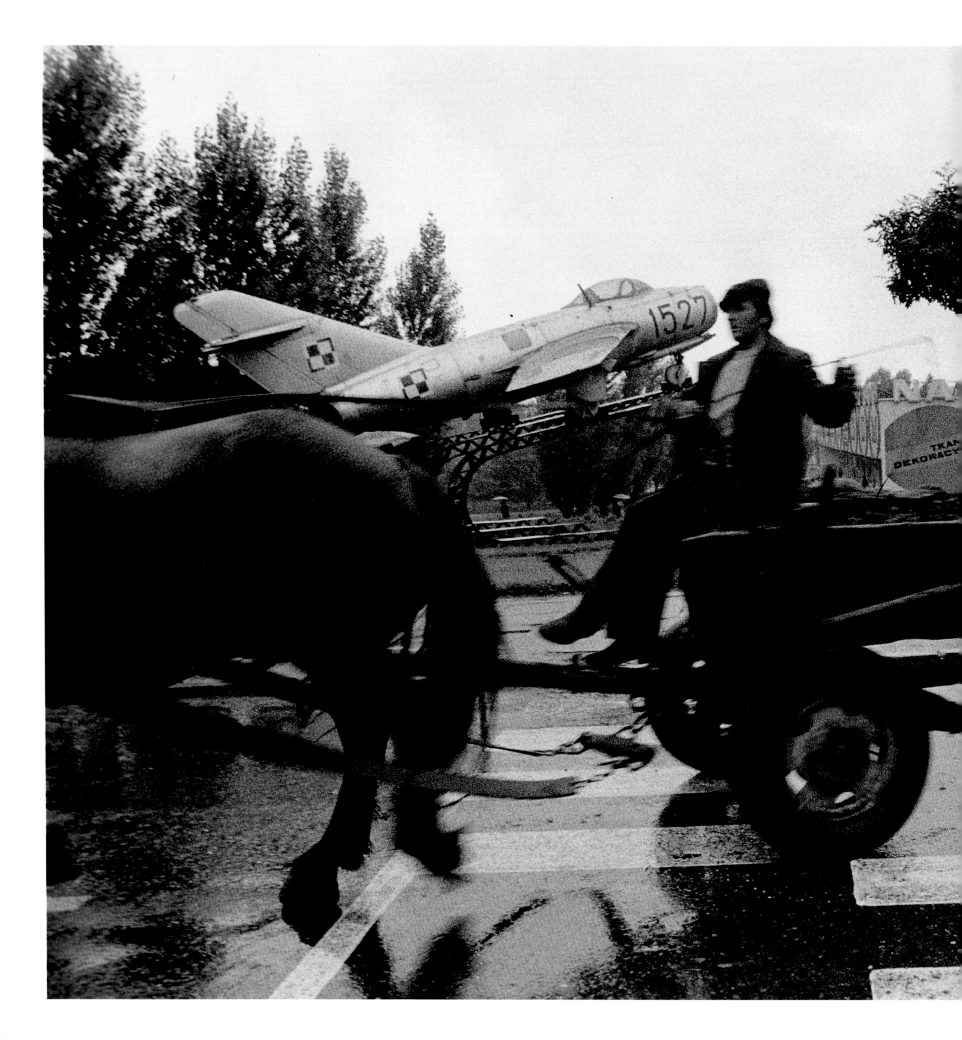

Coal Delivery, Poland 1978

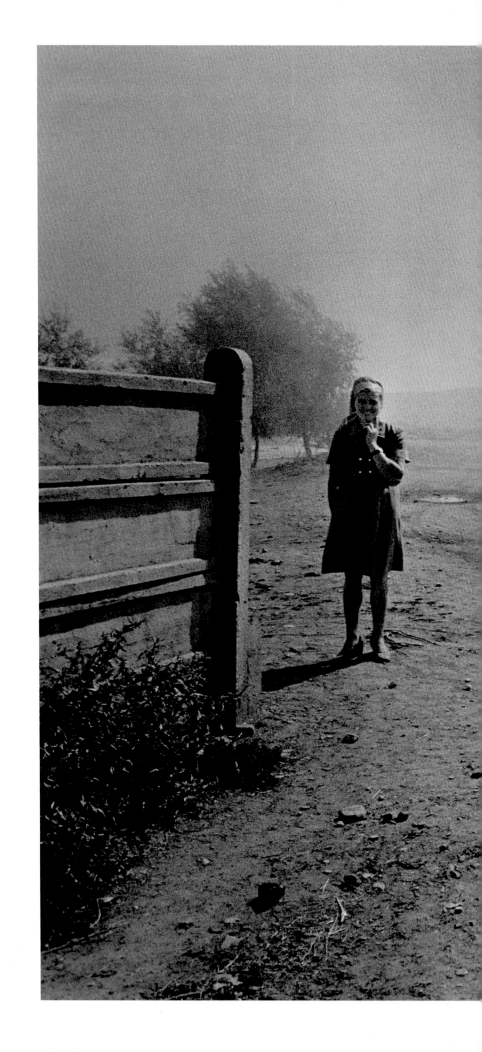

Sunday Market, Romania 1979

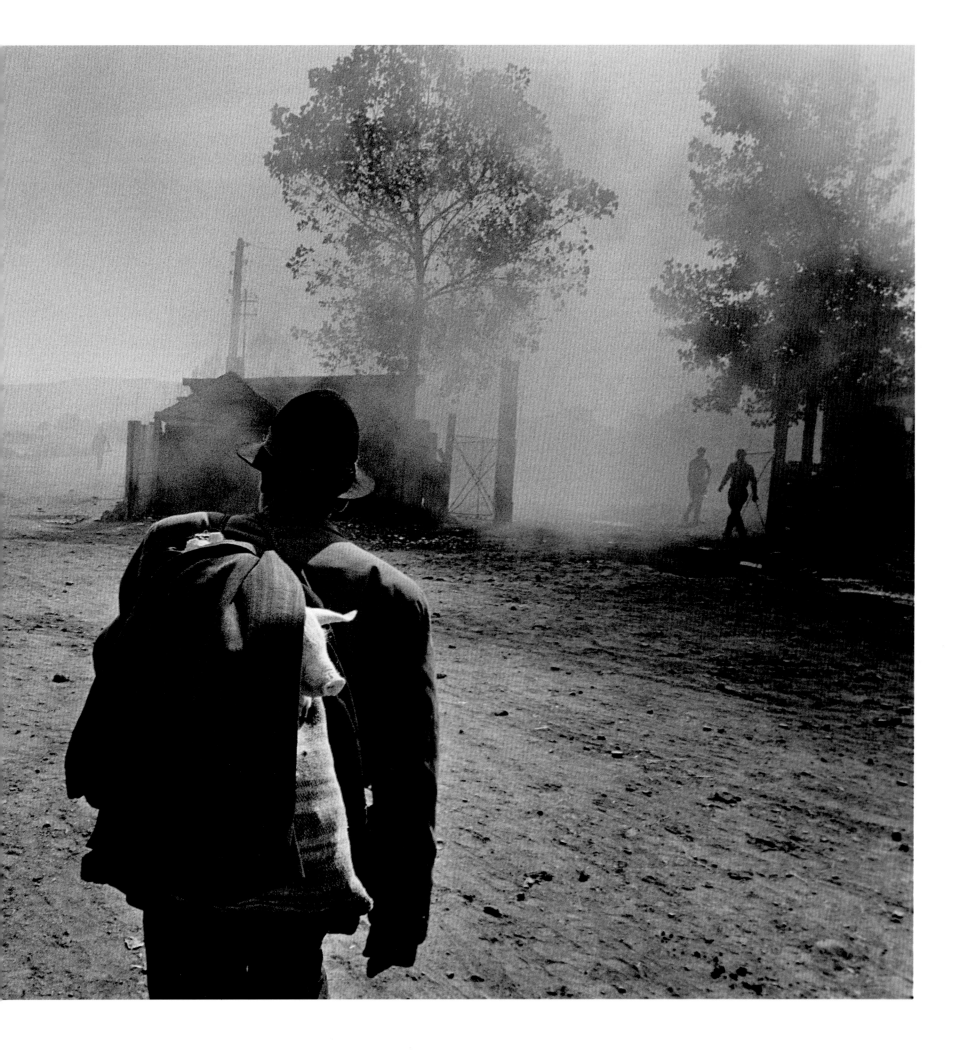

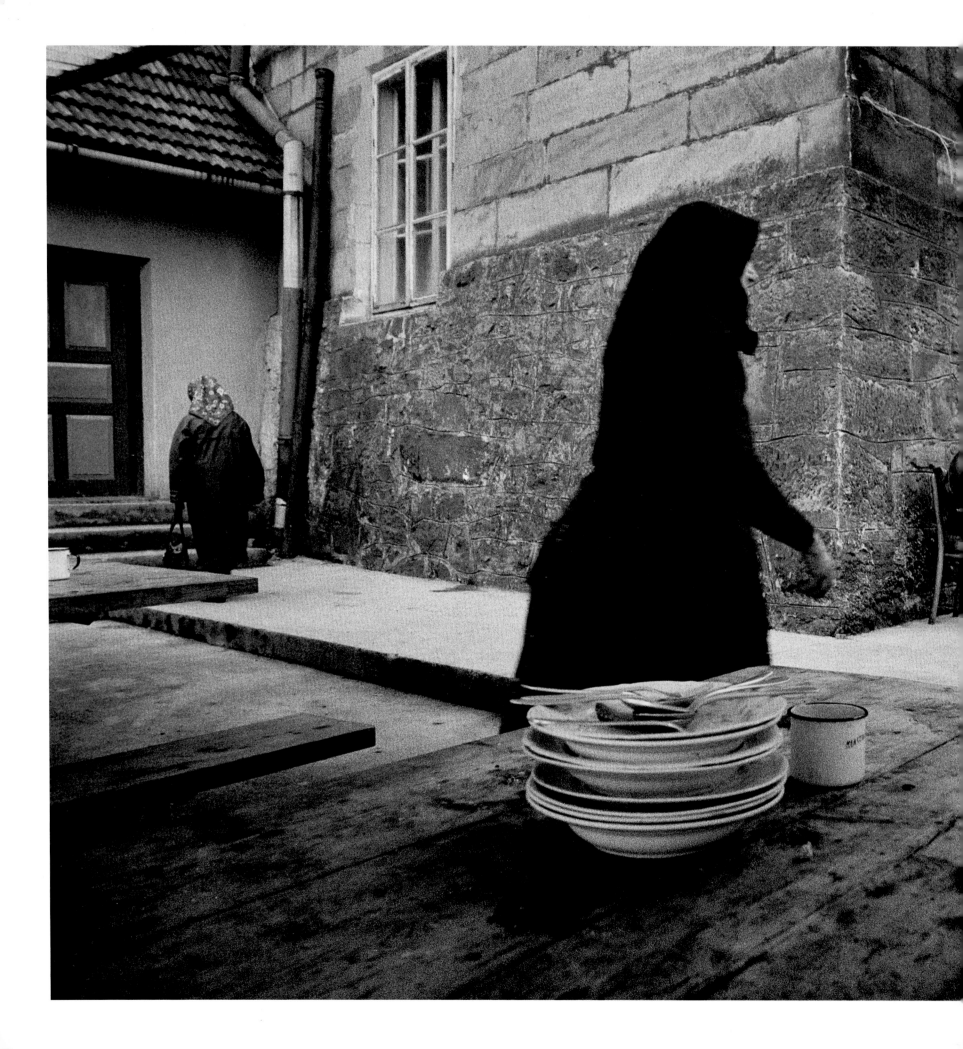

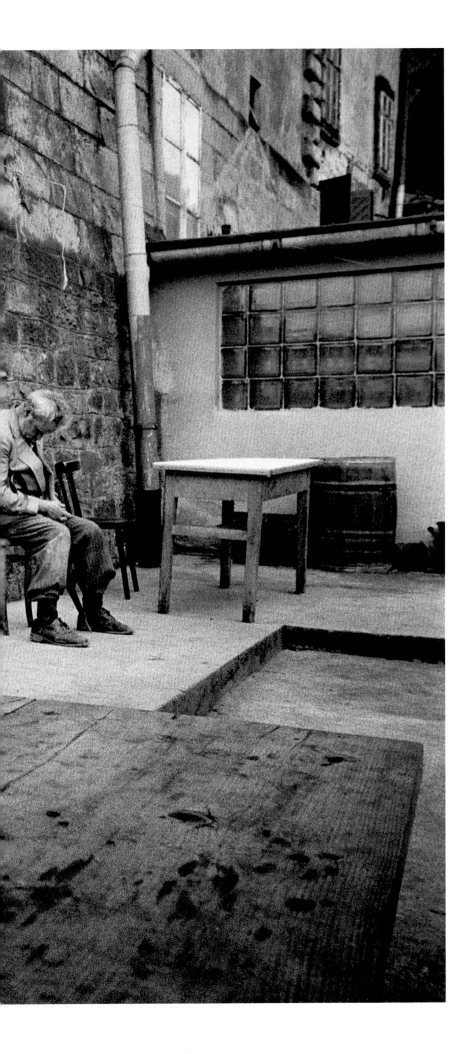

Shelter, Poland 1976

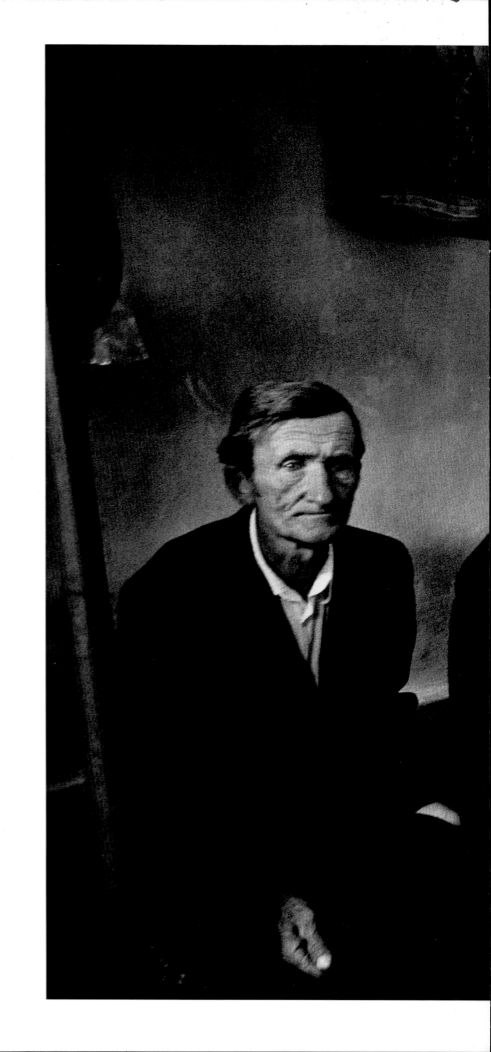

Funeral, Romania 1978

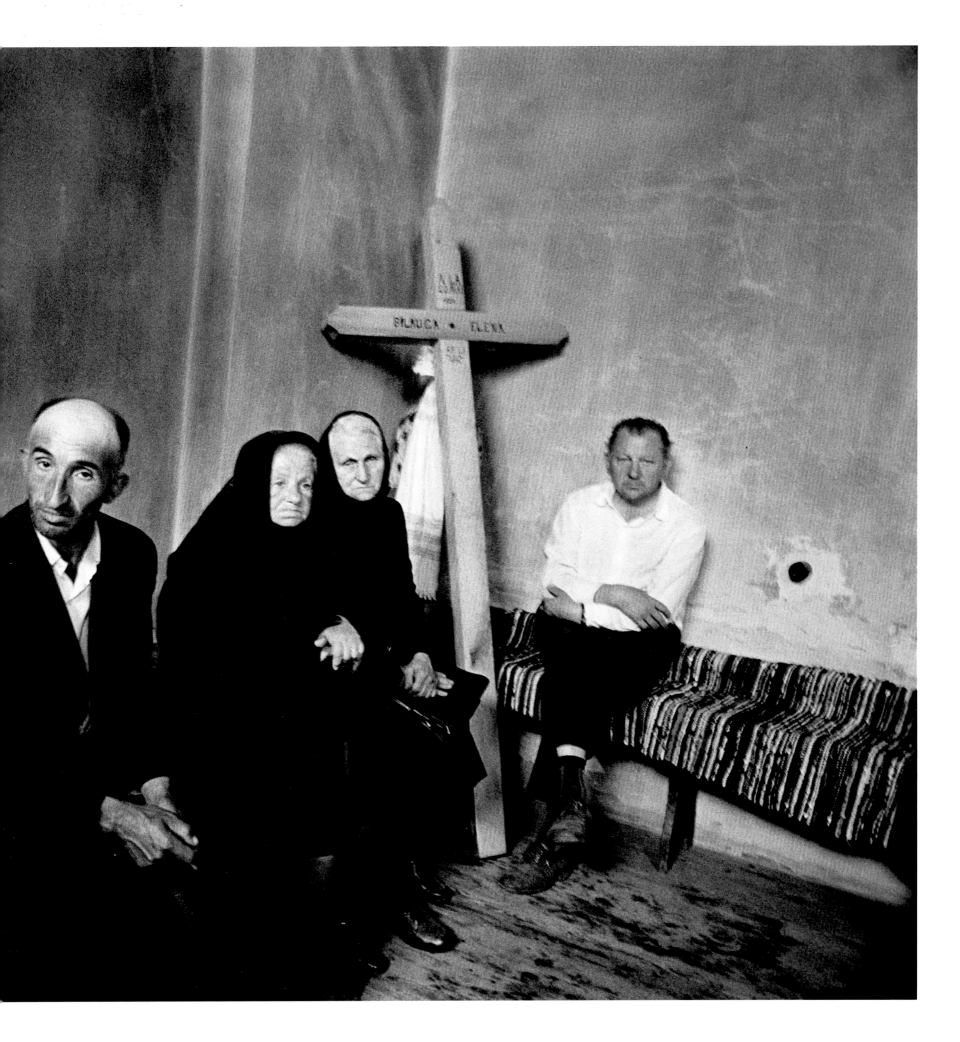

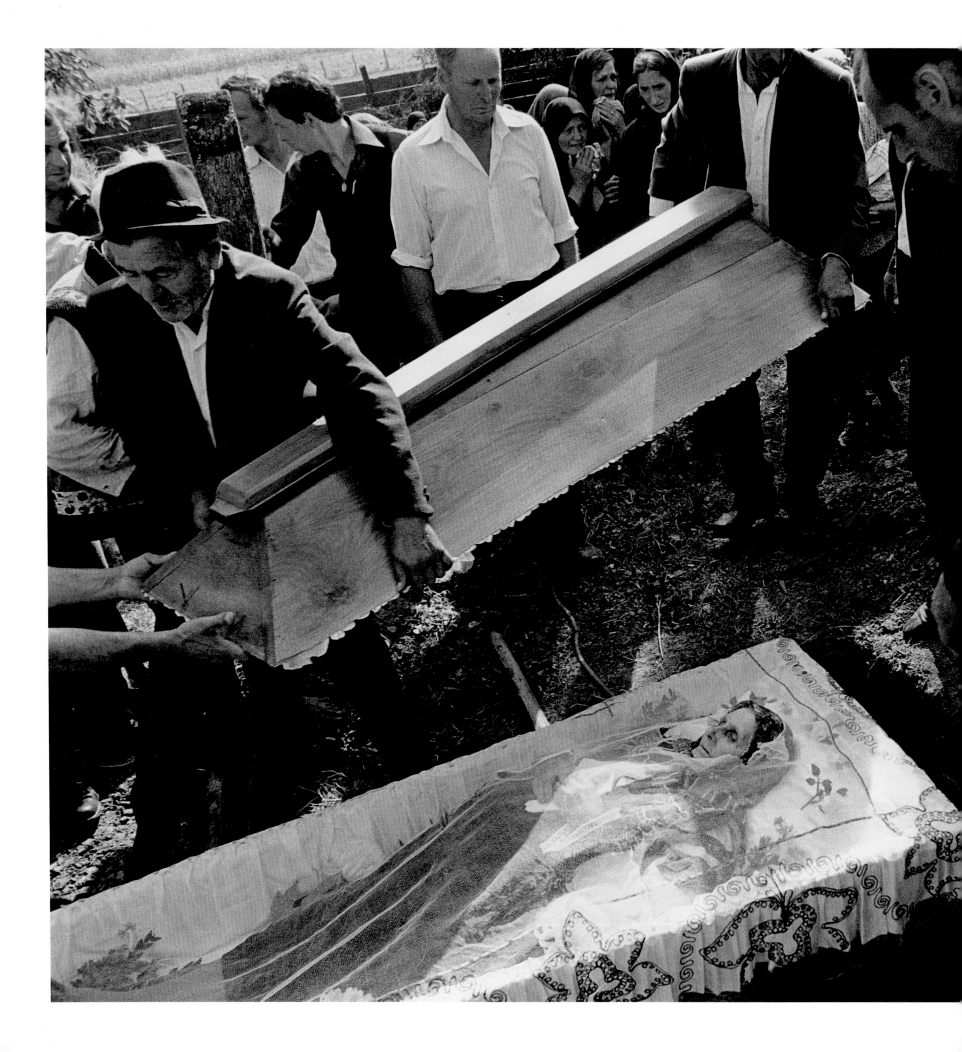

Burial, Romania 1989

Mourners, Soviet Union 1989

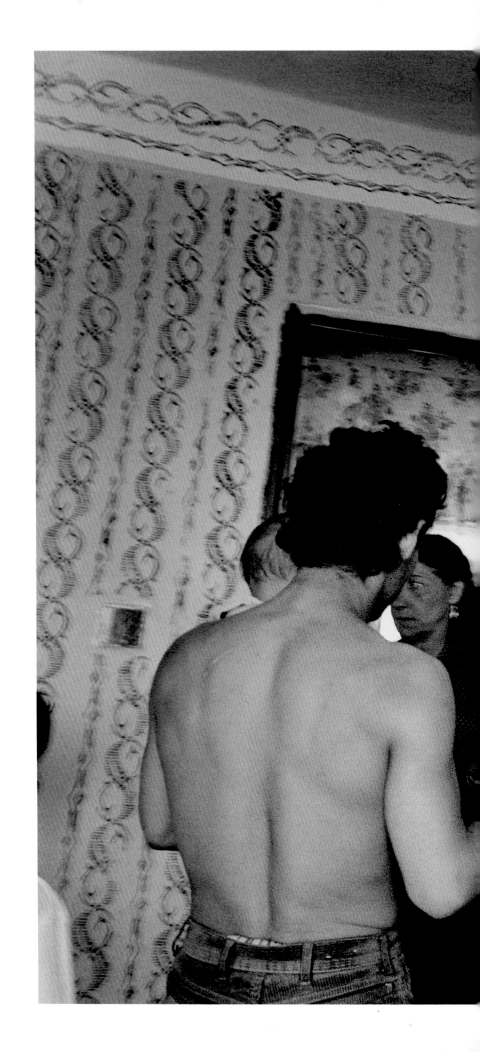

Gypsies, Czechoslovakia 1989

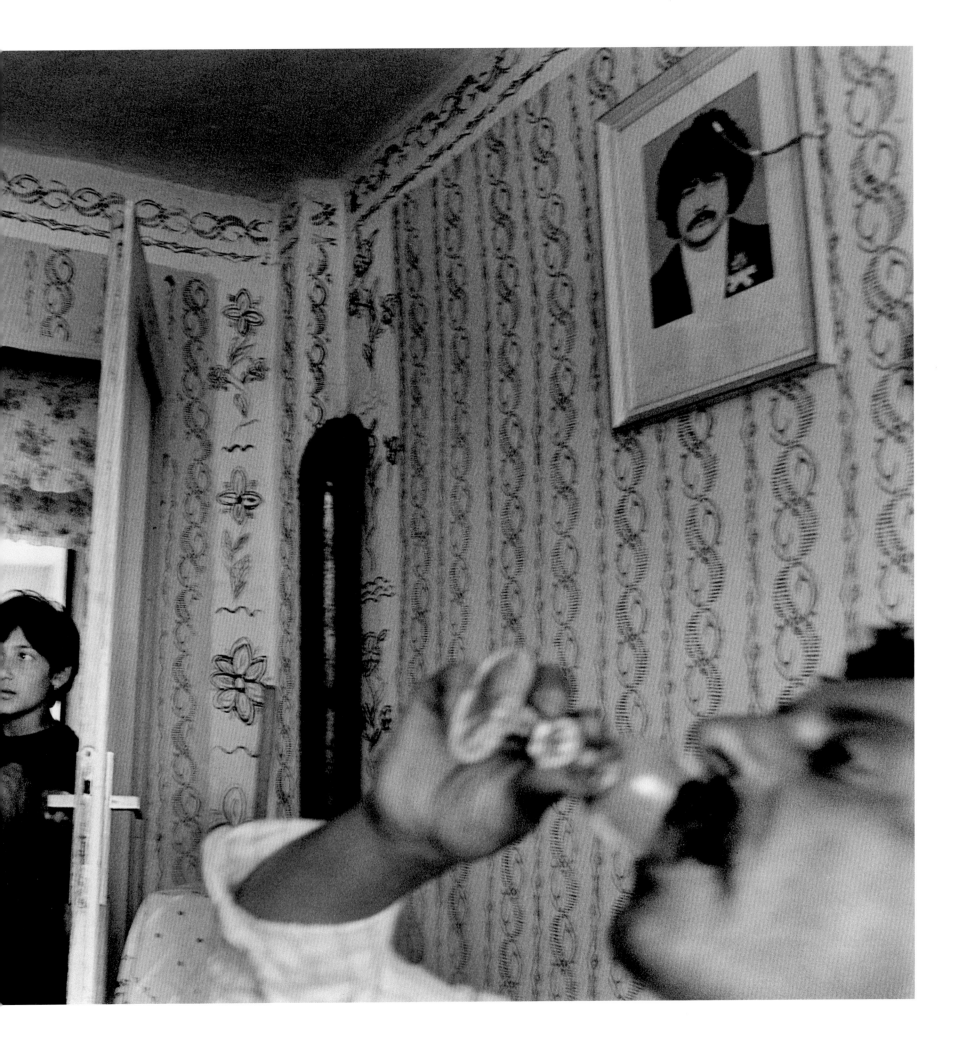

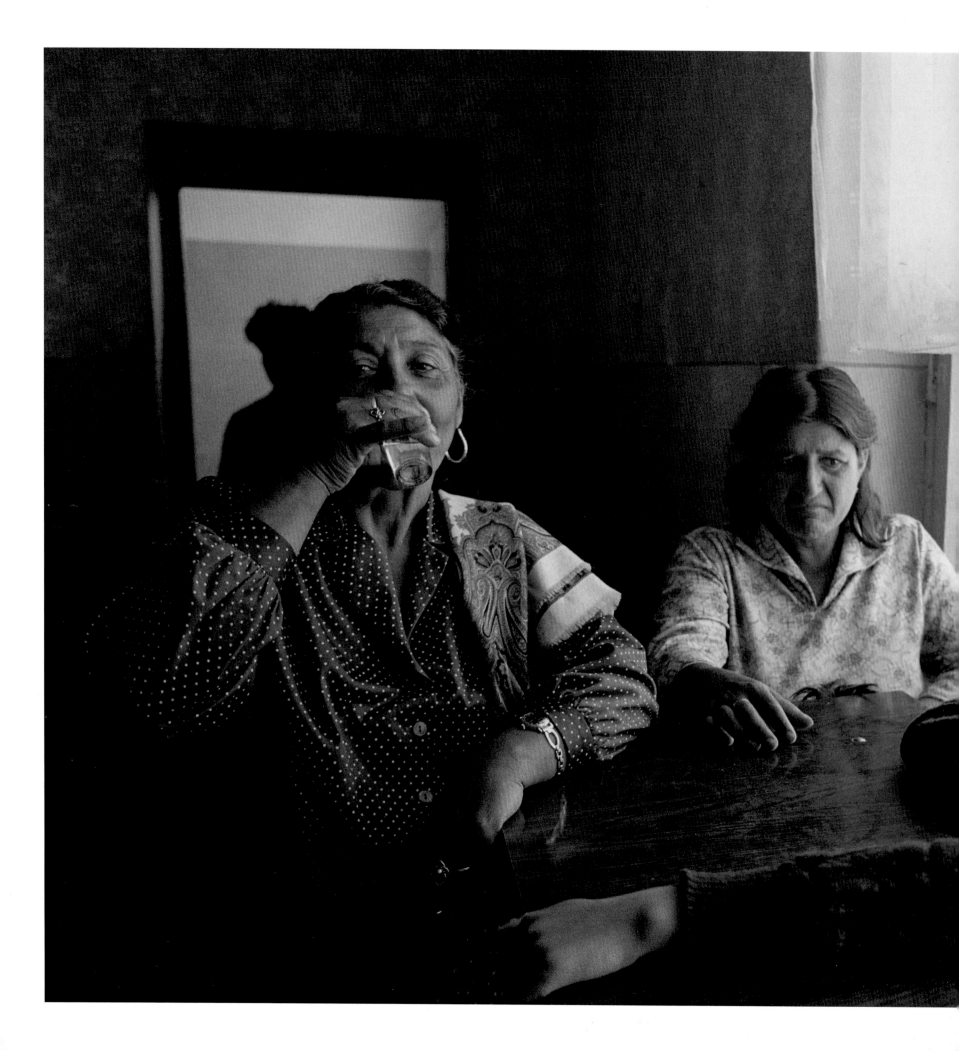

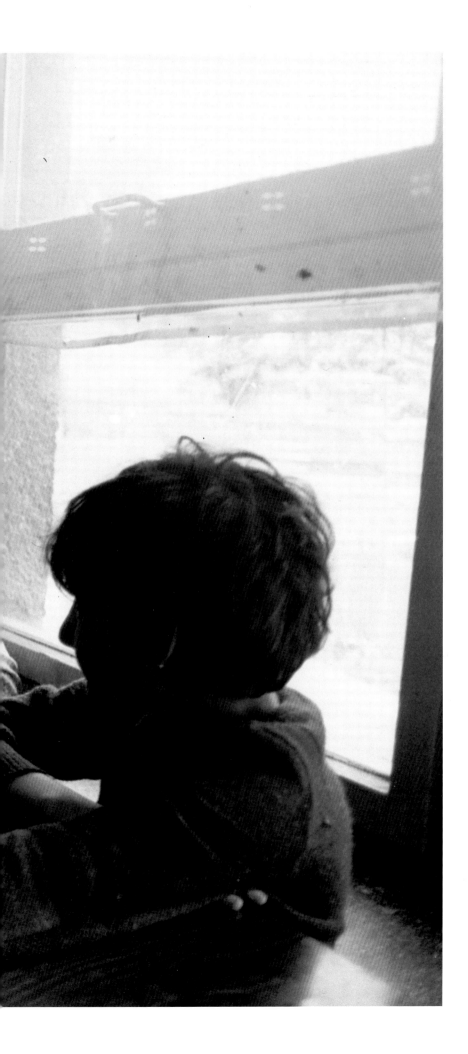

Gypsy Bar, Czechoslovakia 1989

Idling Waitress, Poland 1979

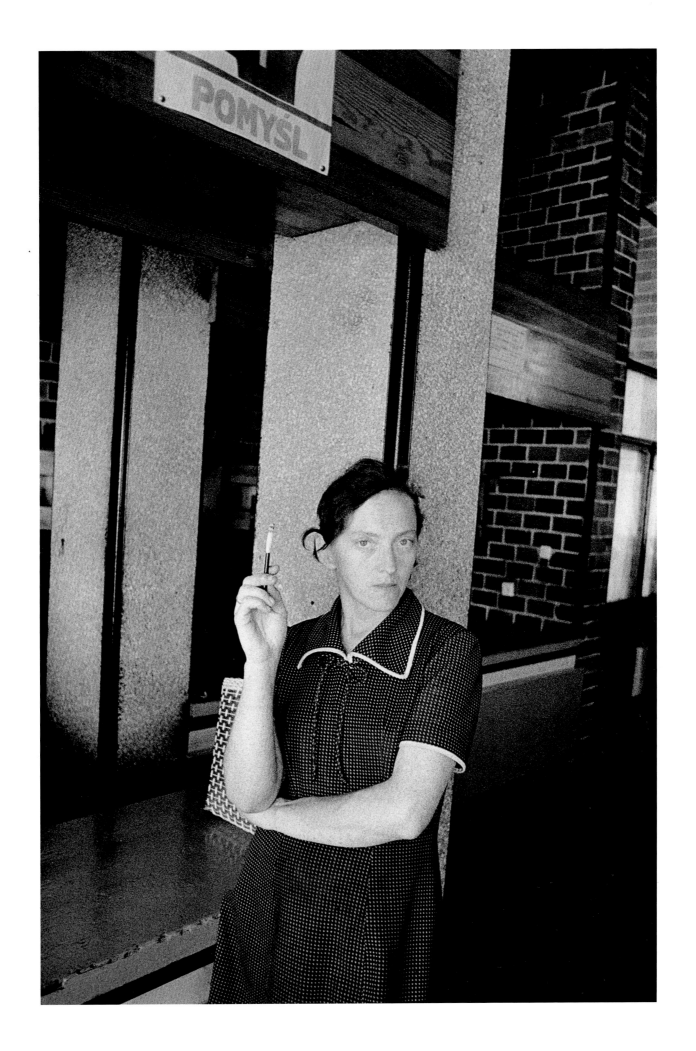

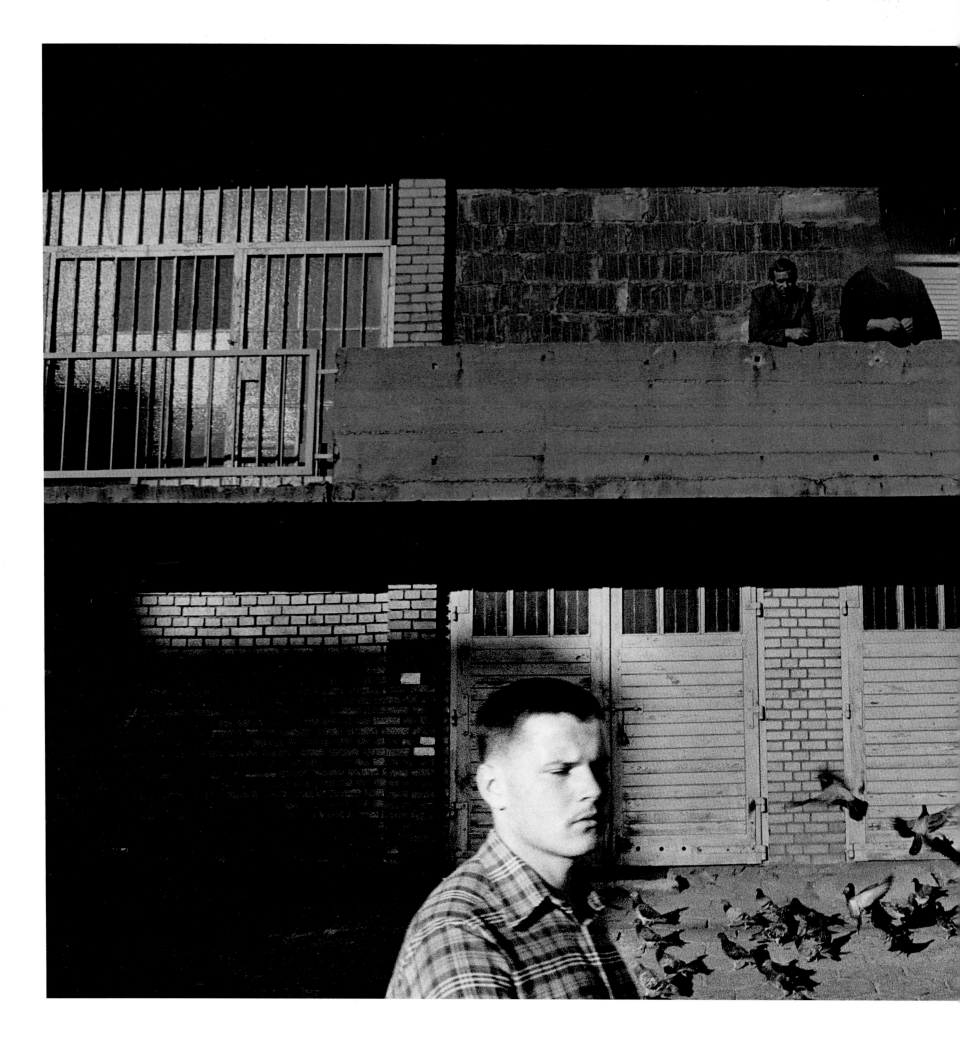

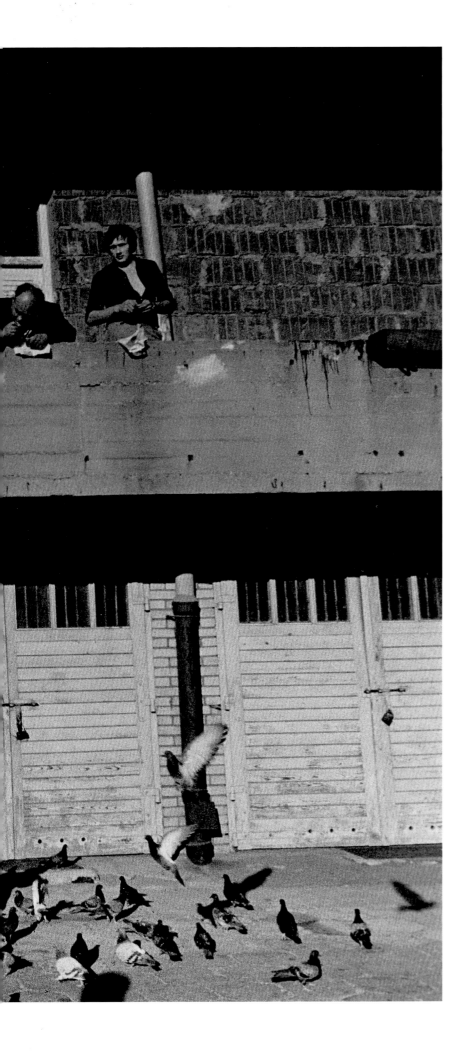

Workers' Housing, Poland 1980

The Granite of Saint Anna, Poland 1971

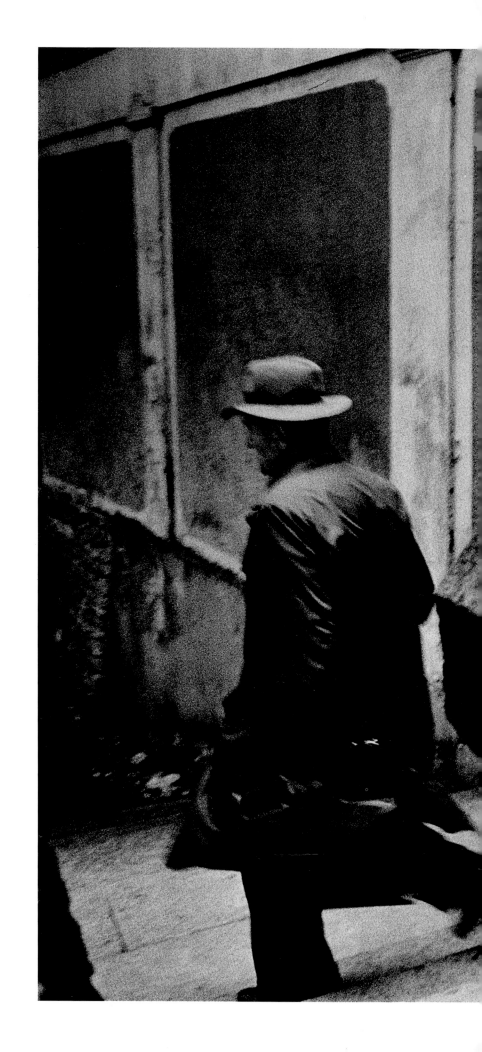

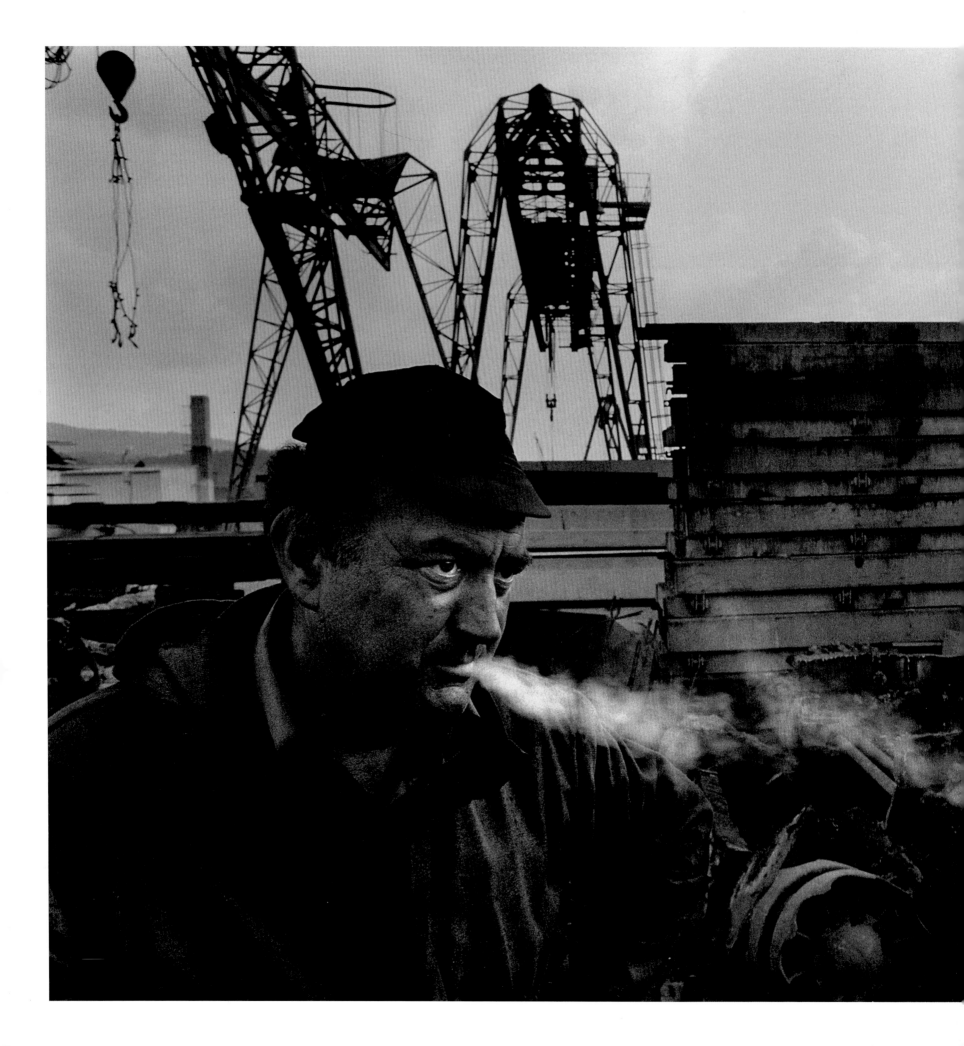

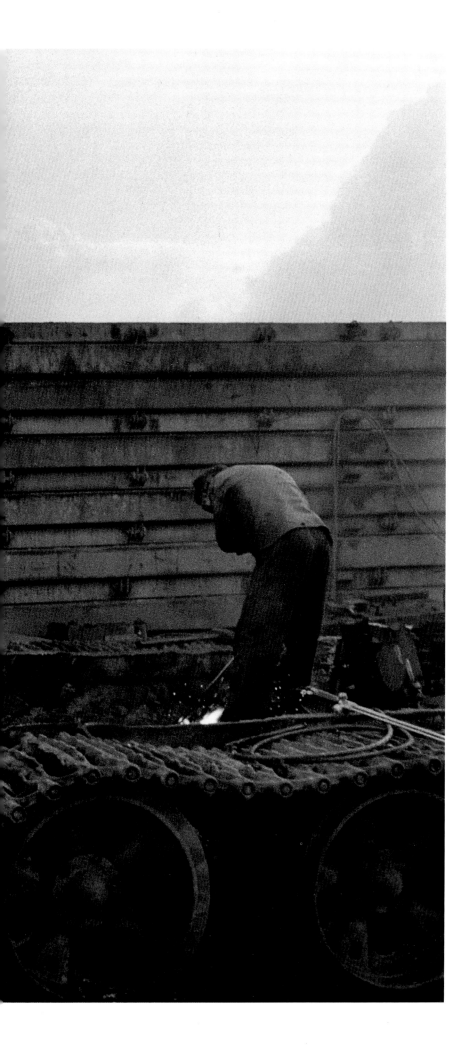

Tank Destroyer, Czechoslovakia 1991

Museum of Socialist Realism, Hungary 1995

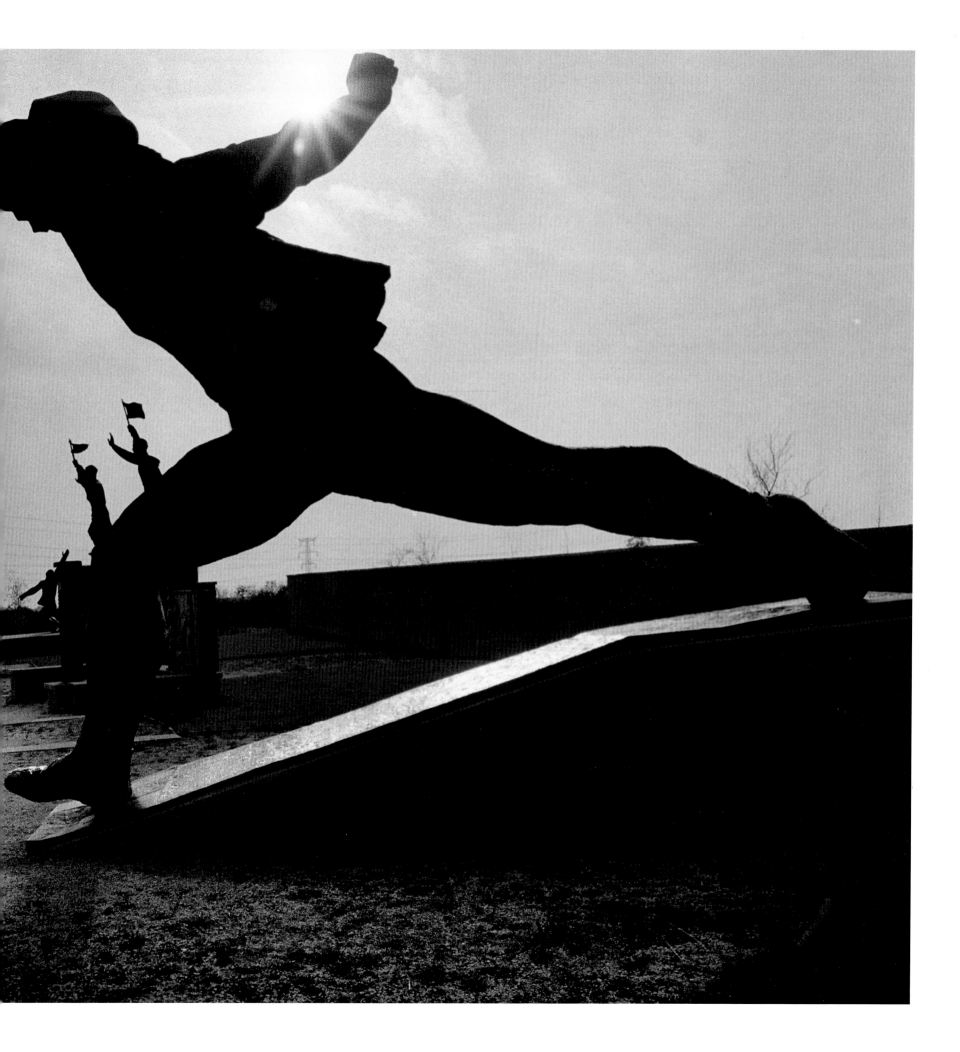

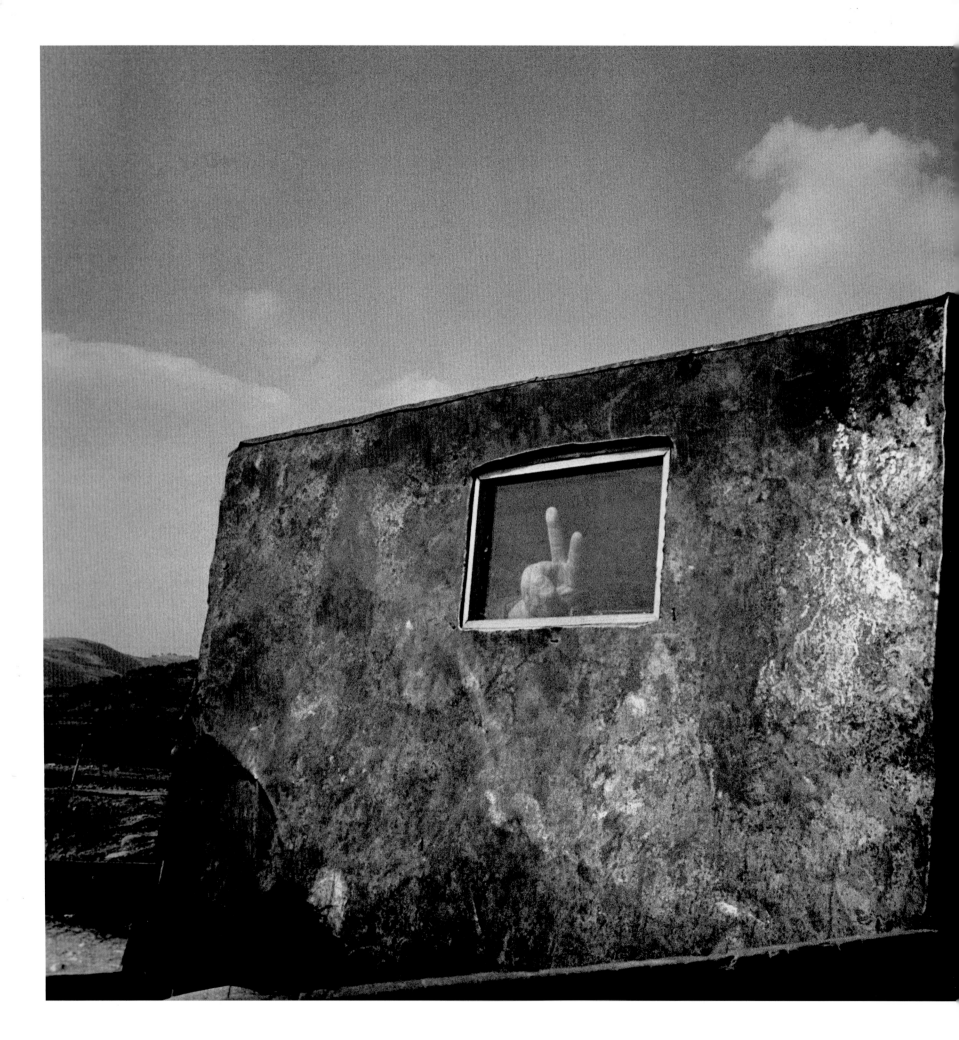

Victory SIgn, Albanian Gulag, Albania 1991

In the Field of the New Gods, Romania 1995

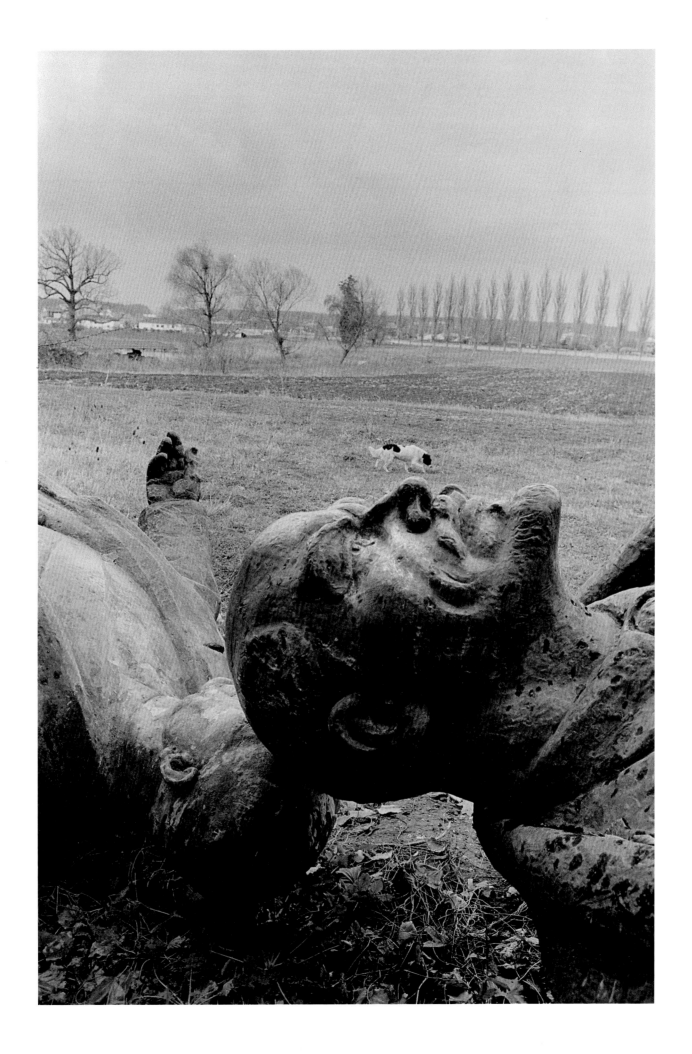

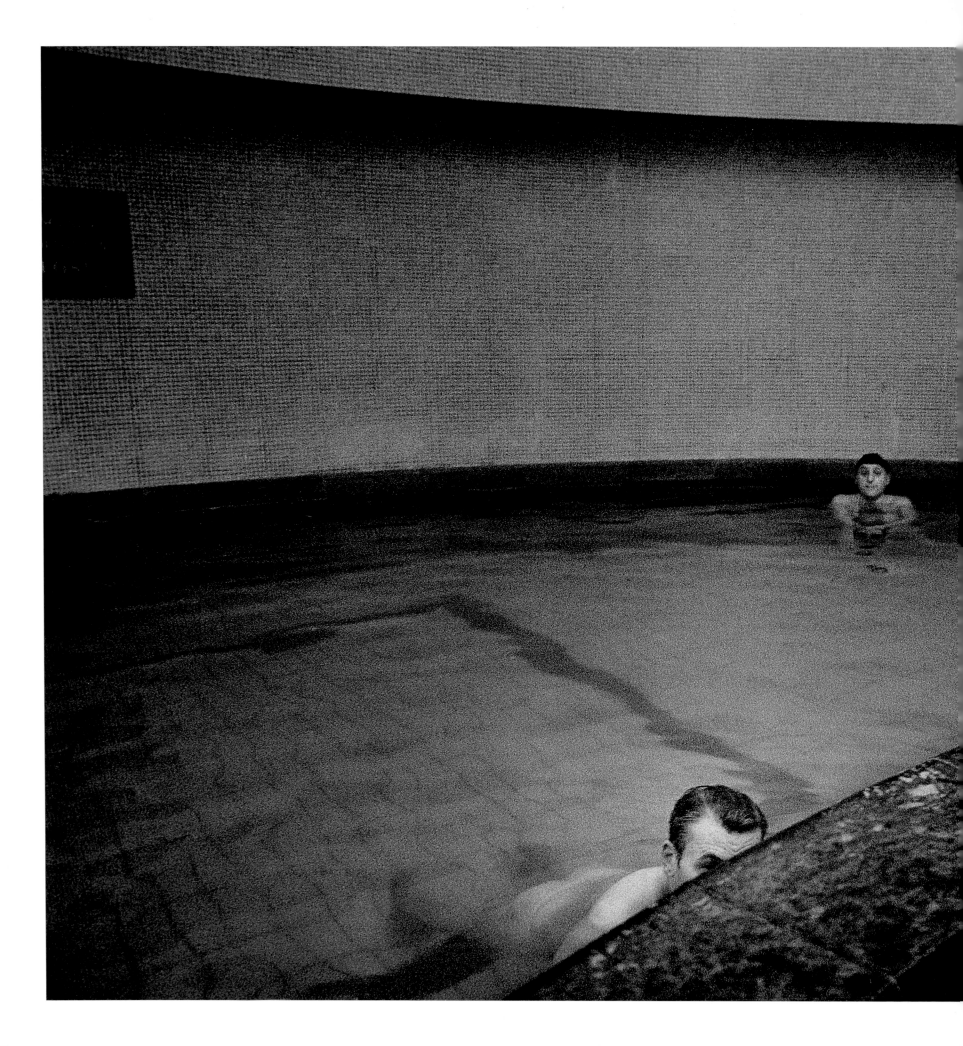

Suspicion, Hungary 1992

Museum of the Secret Police, Czechoslovakia 1989

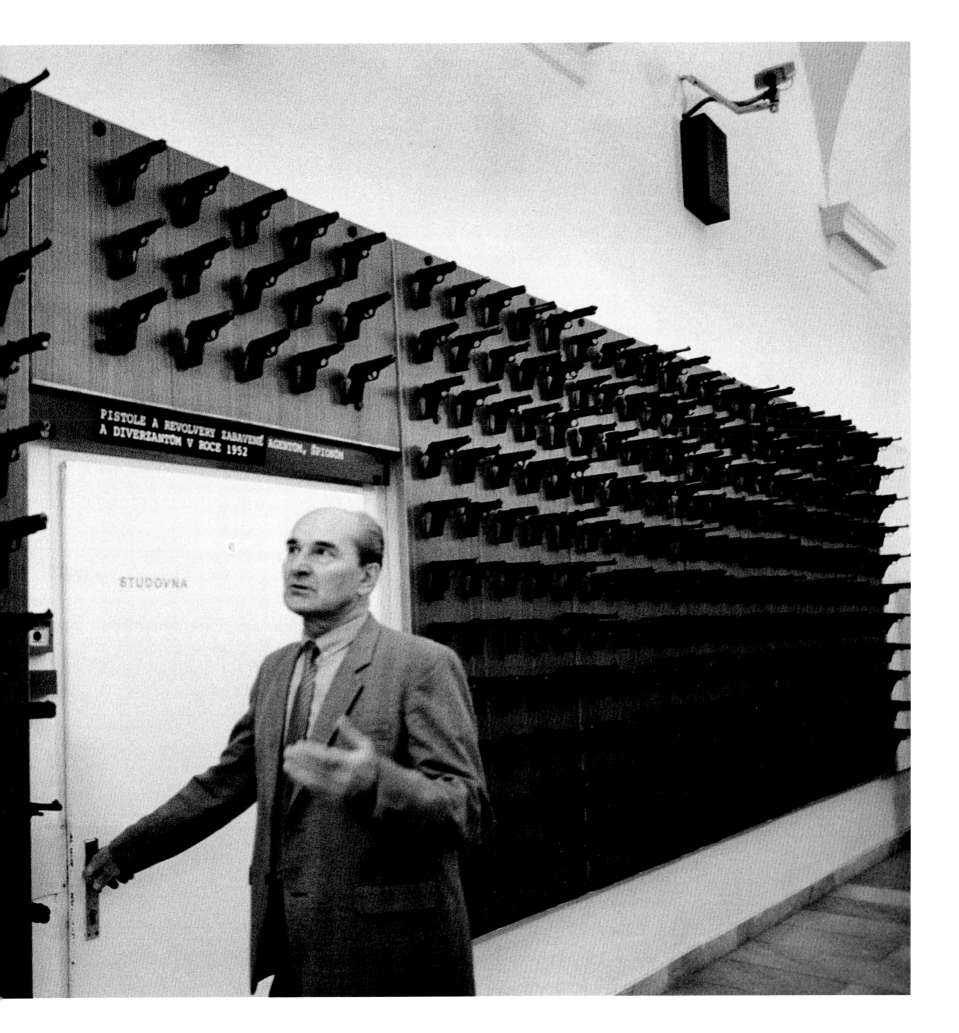

STUDOVNA

PISTOLE A REVOLVERY ZABAVENÉ AGENTŮM, ŠPIONŮM
A DIVERZANTŮM V ROCE 1952

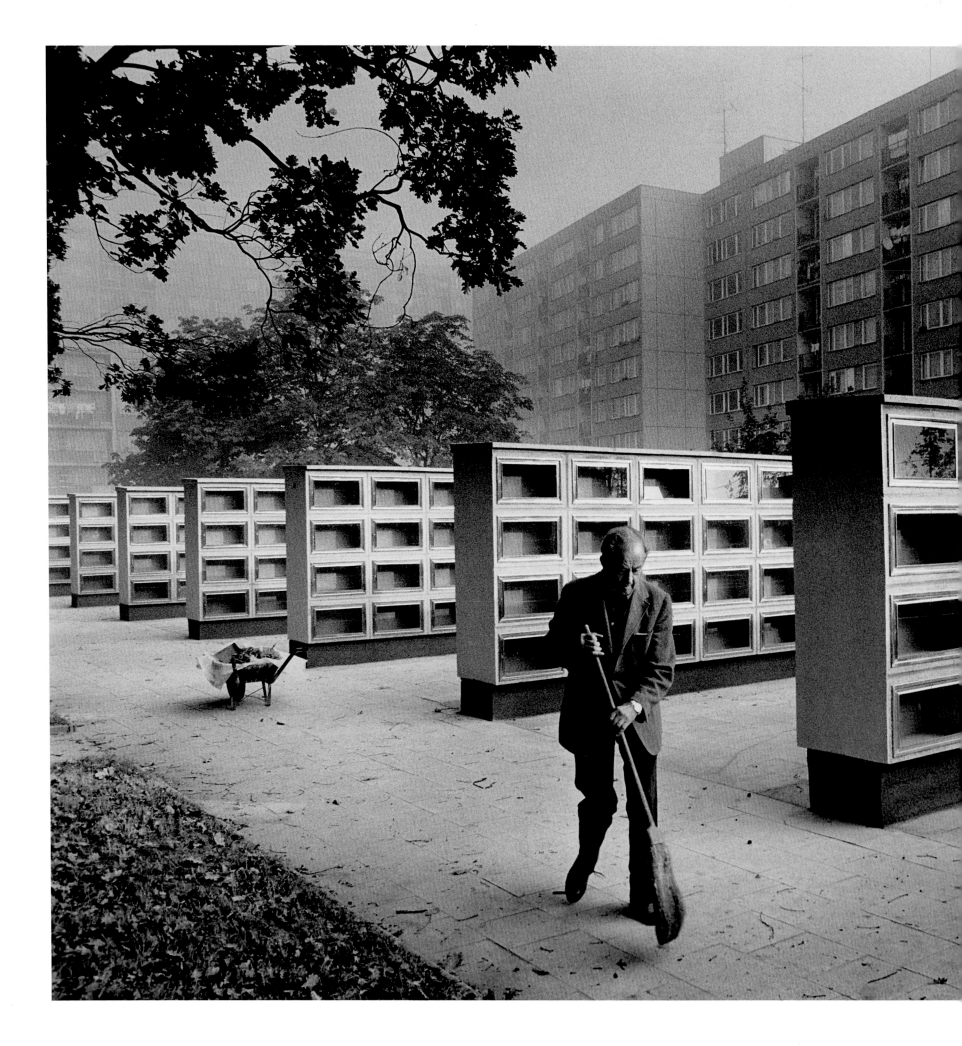

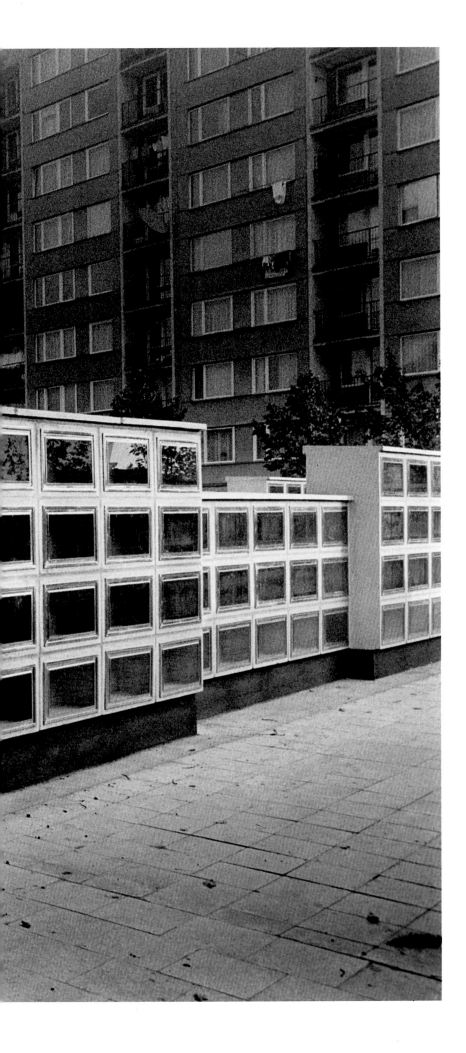

New Cemetery, Satellite City, Czech Republic 1993

Velvet Revolution, Czechoslovakia 1989

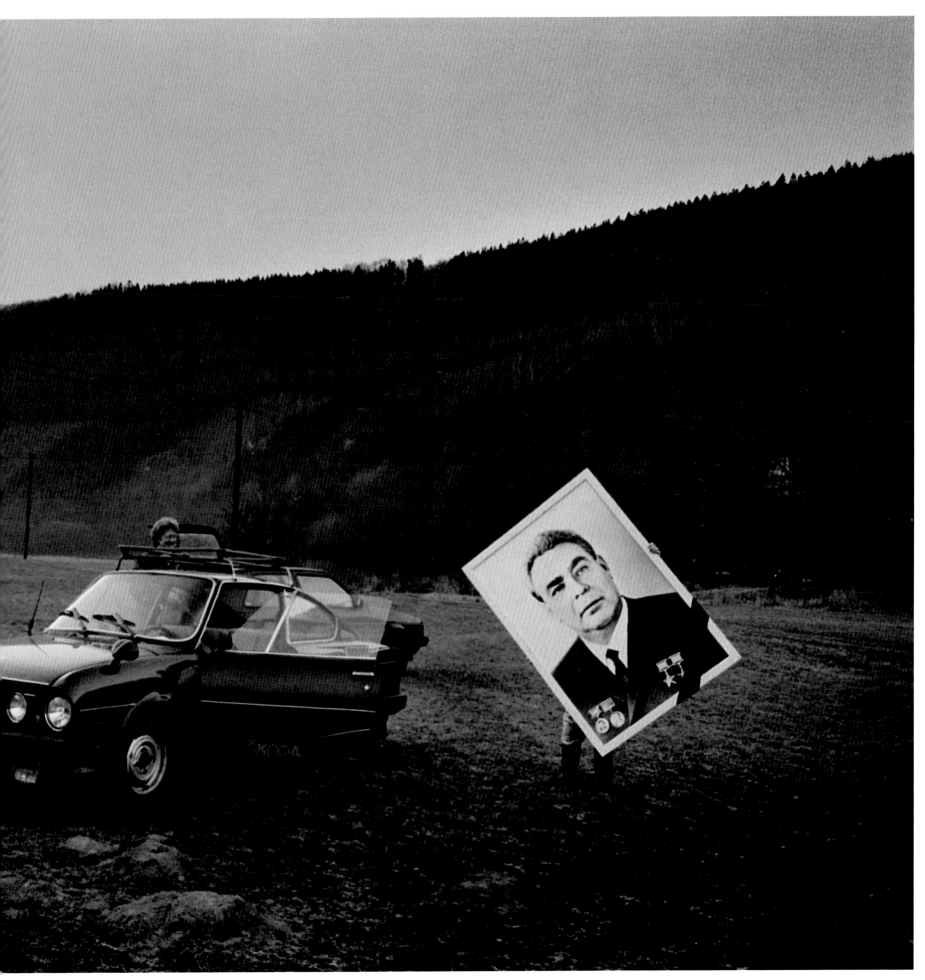

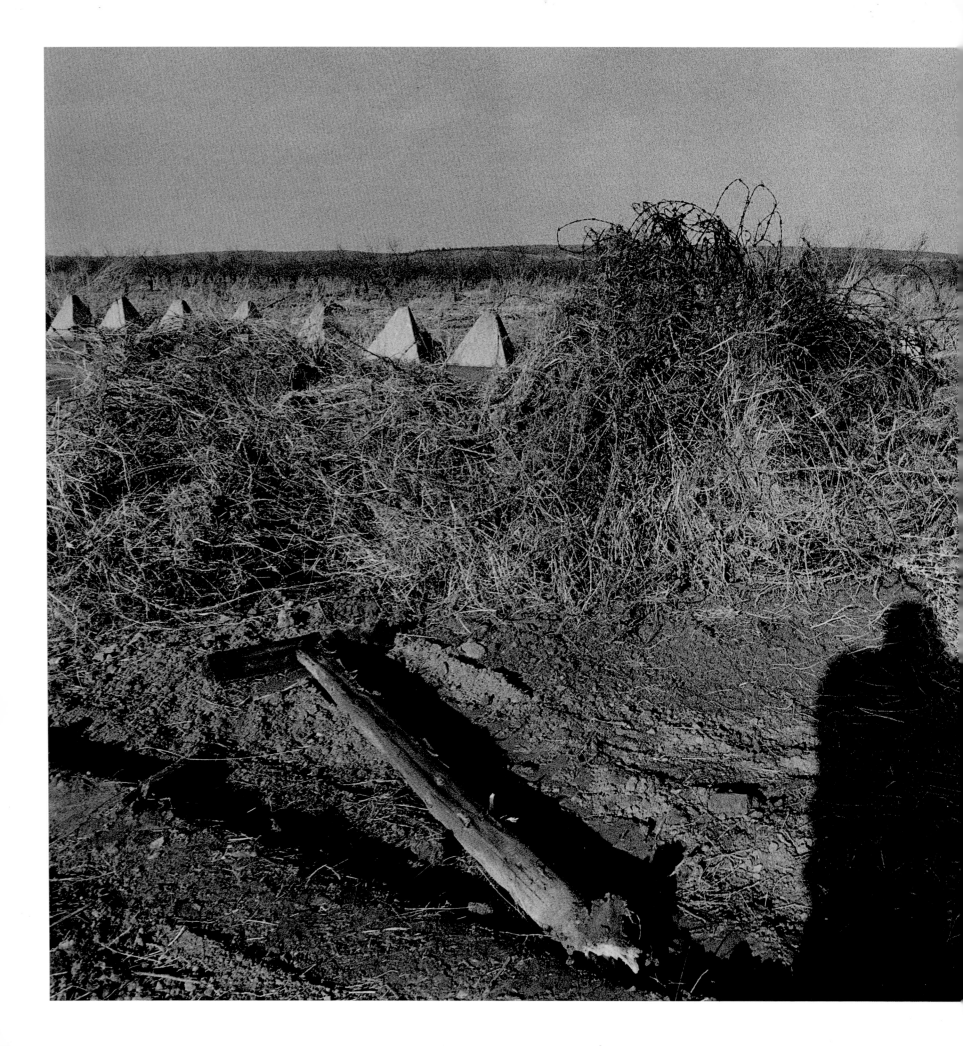

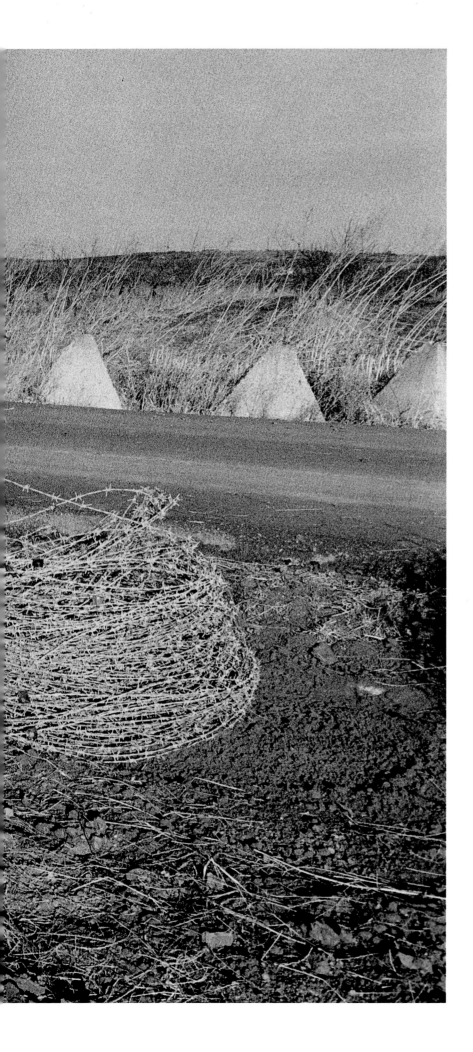

Fallen Iron Curtain, Czechoslovakia 1989

May Day, Russia 1996

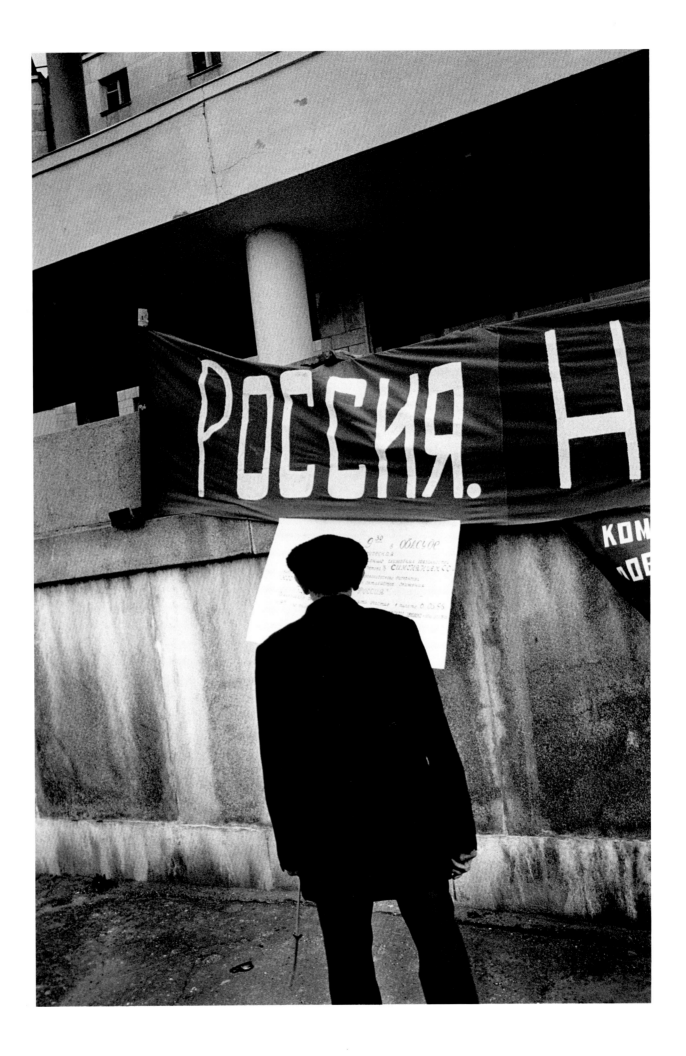

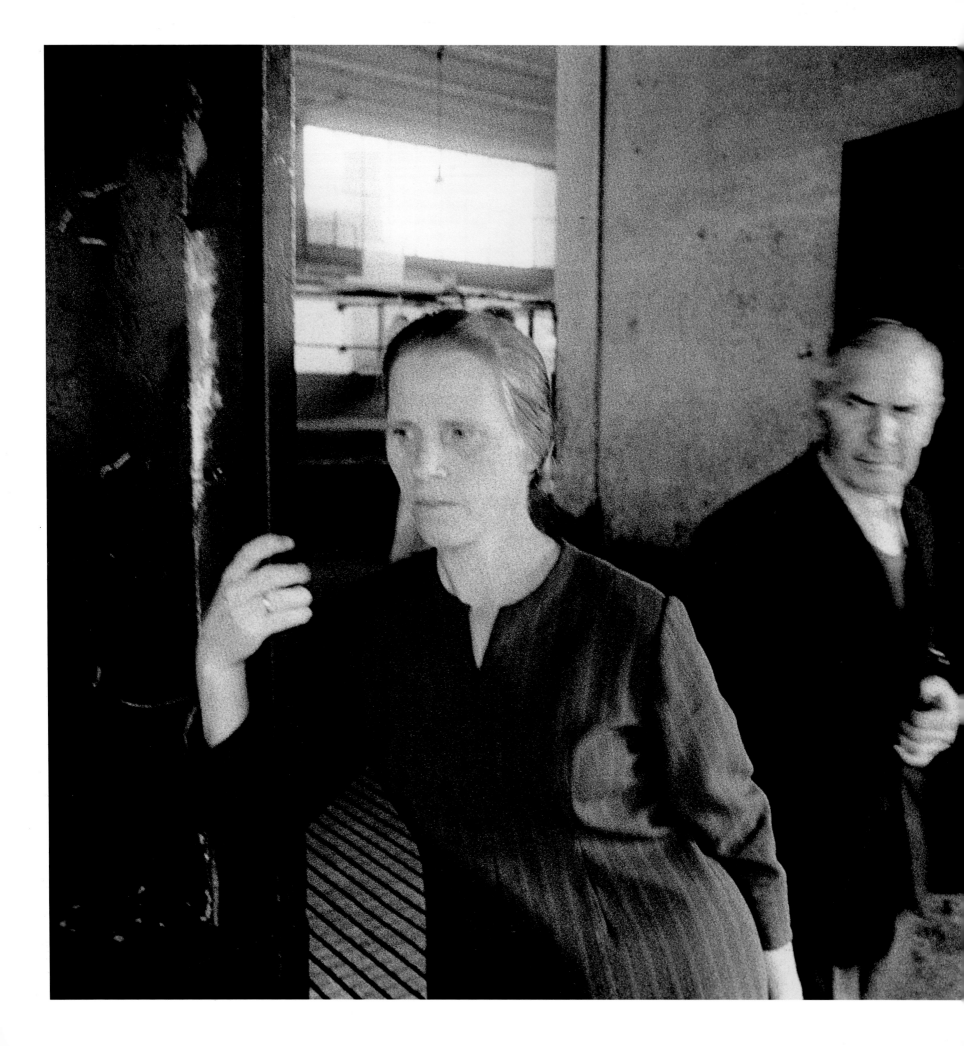

Empty Market, Poland 1976

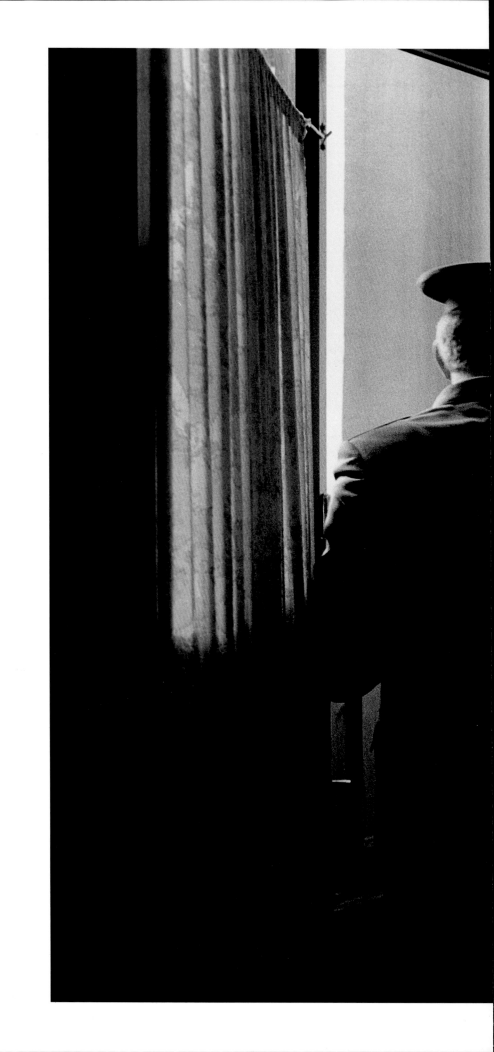

Minister of the Interior, Soviet Union 1989

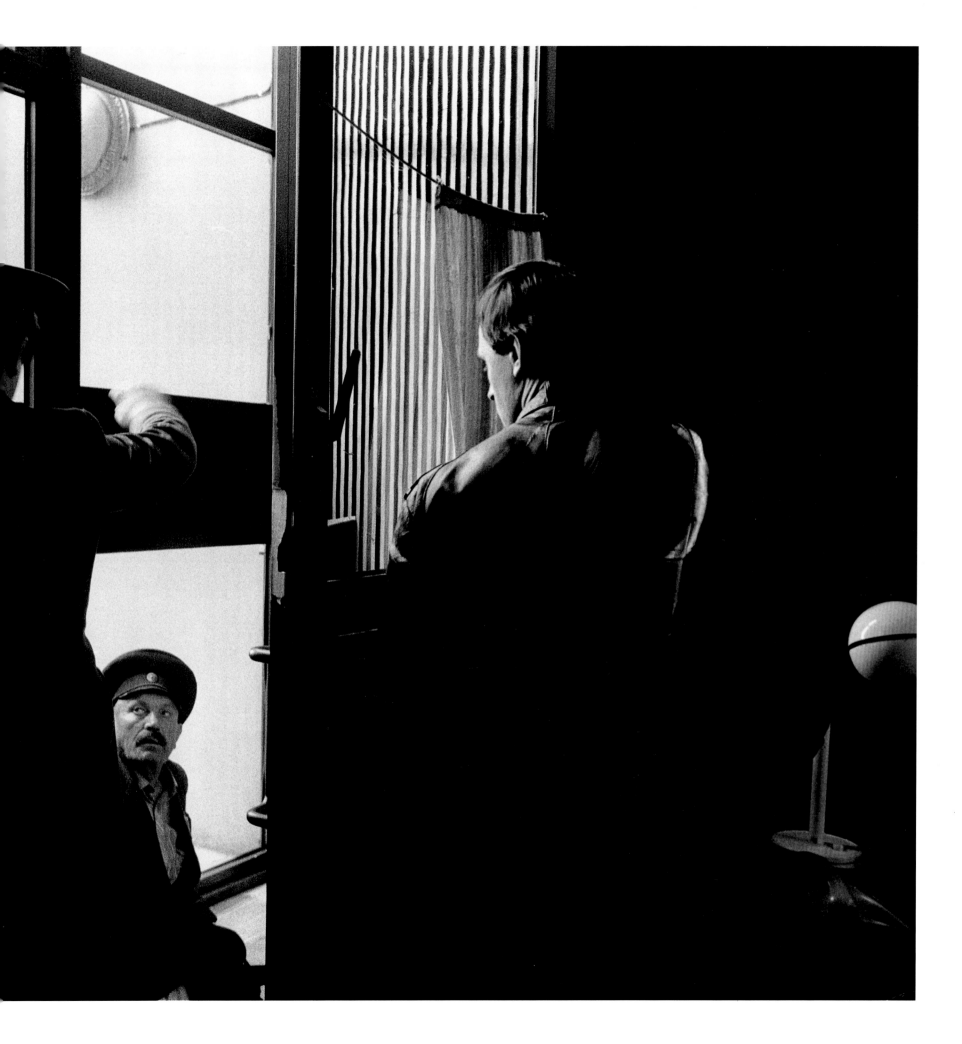

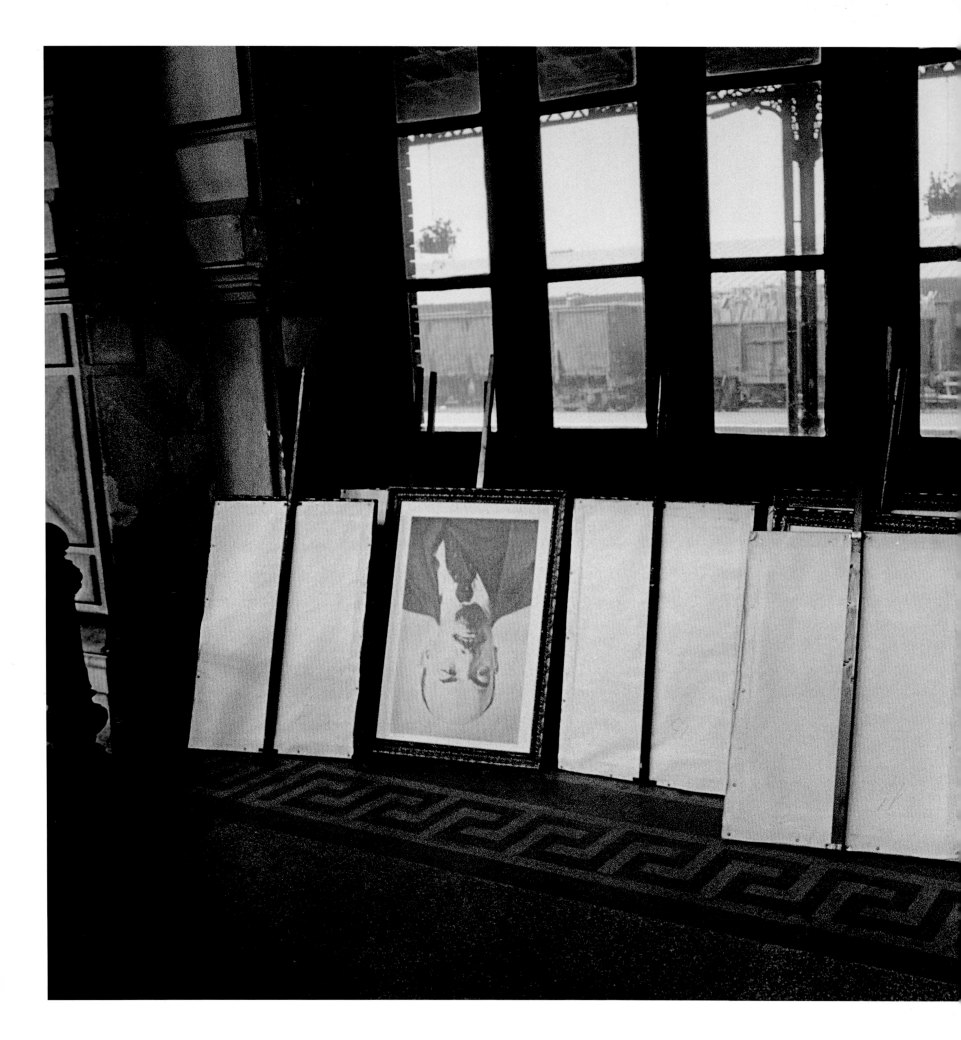

Before the Parade, Romania 1978

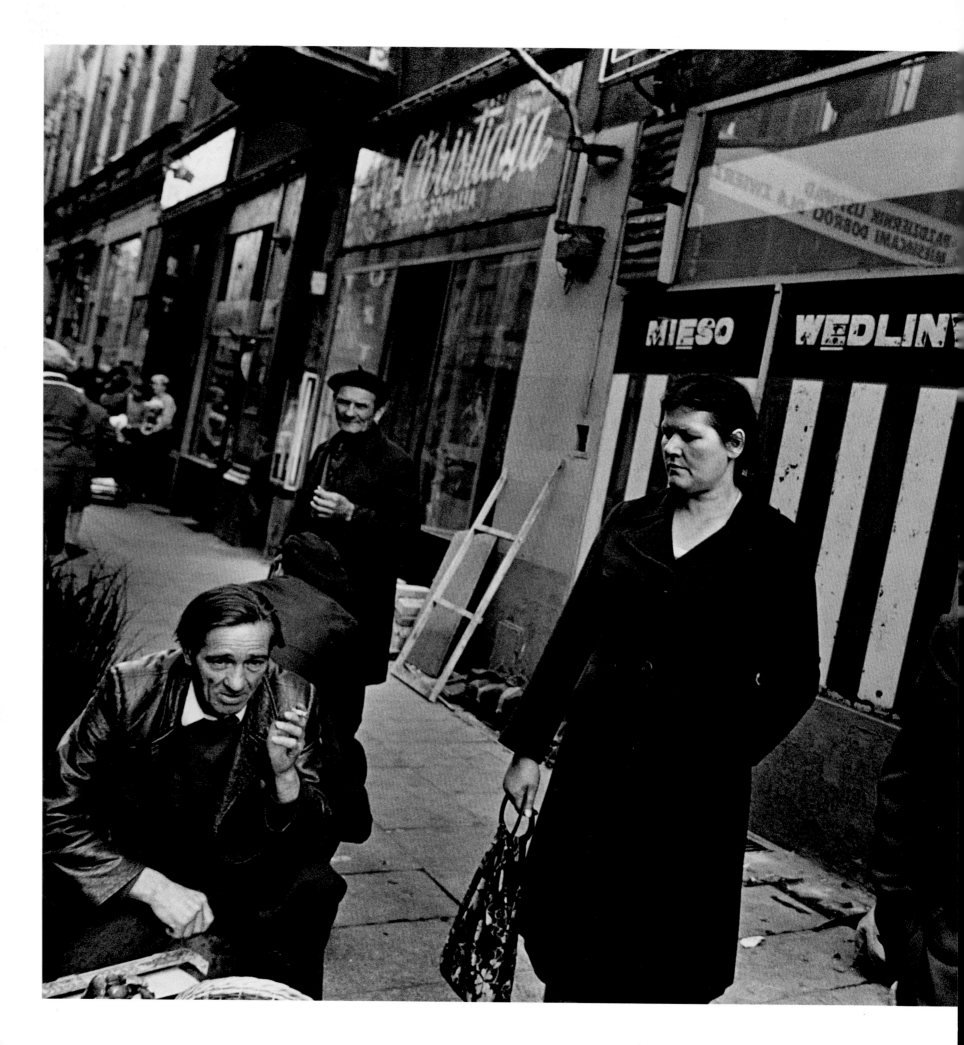

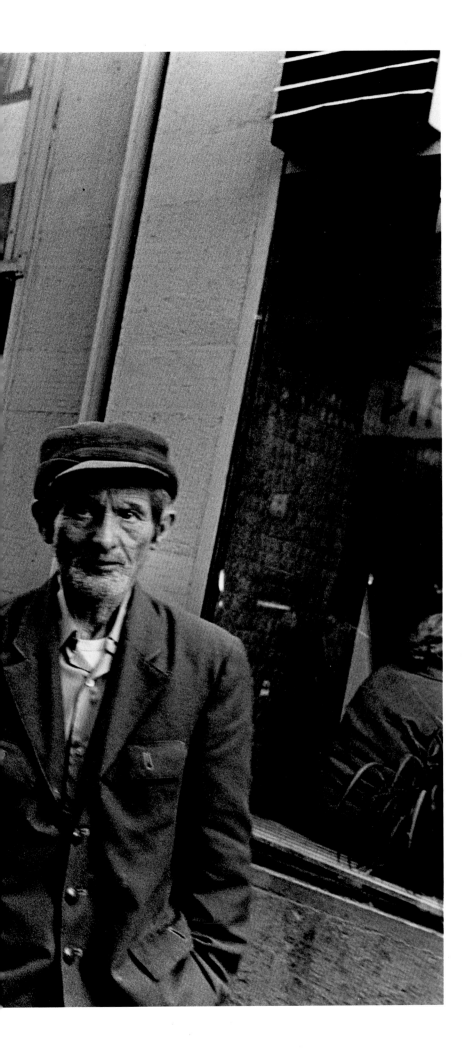

Food Crisis, Poland 1979

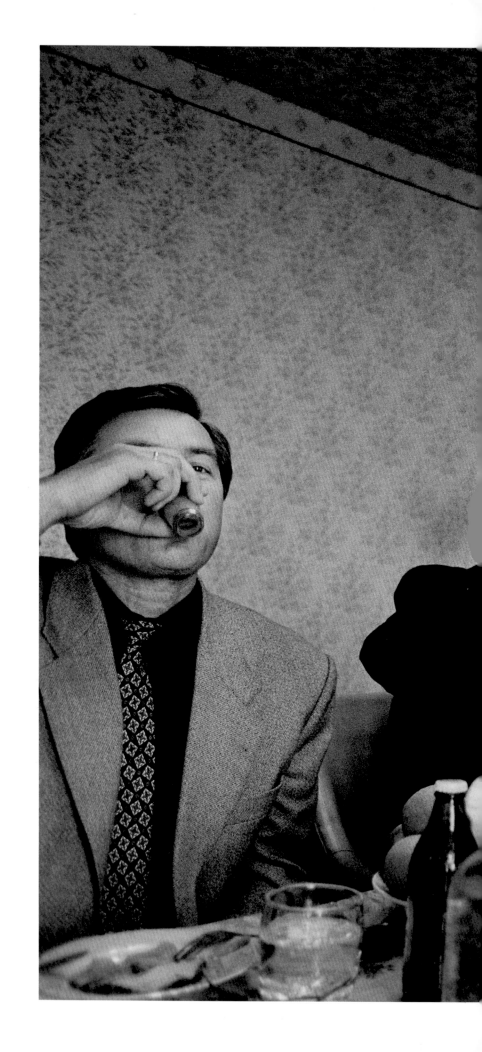

More Equal Among the Equal, Russia 1996

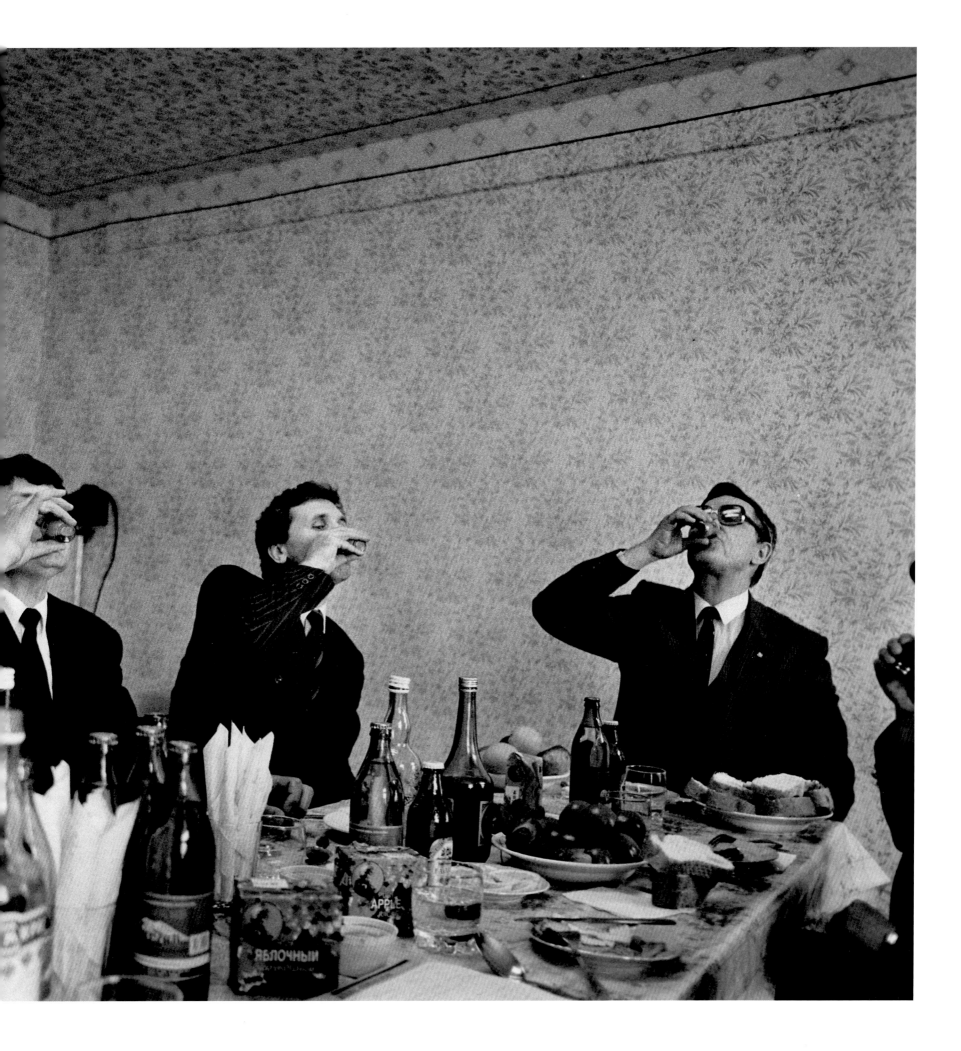

Stalin's Cake, Romania 1995

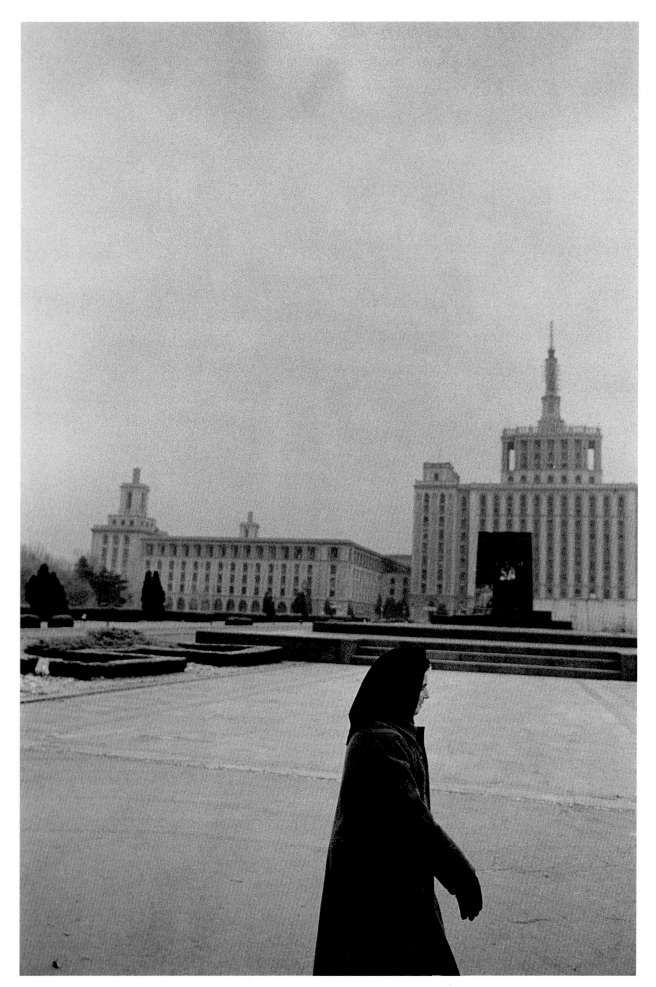

Anti-Government Demonstration, Poland 1976

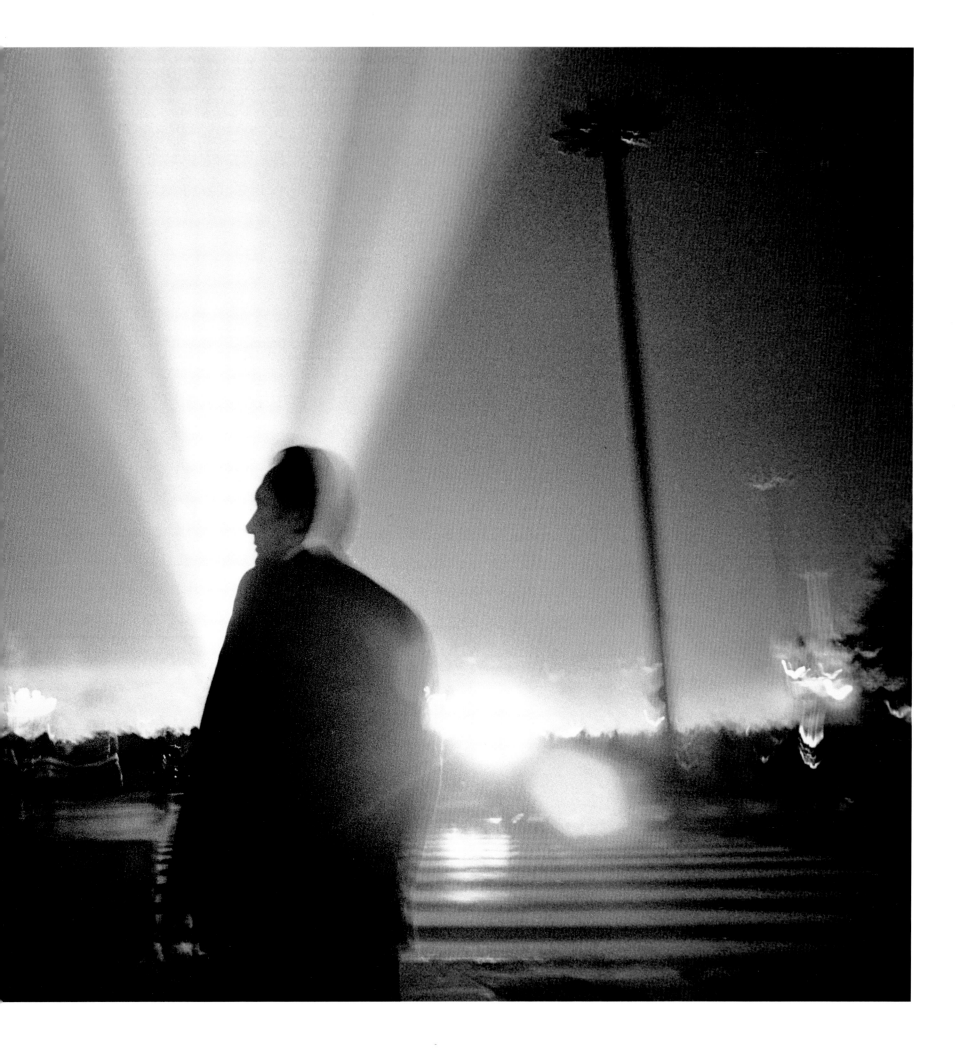

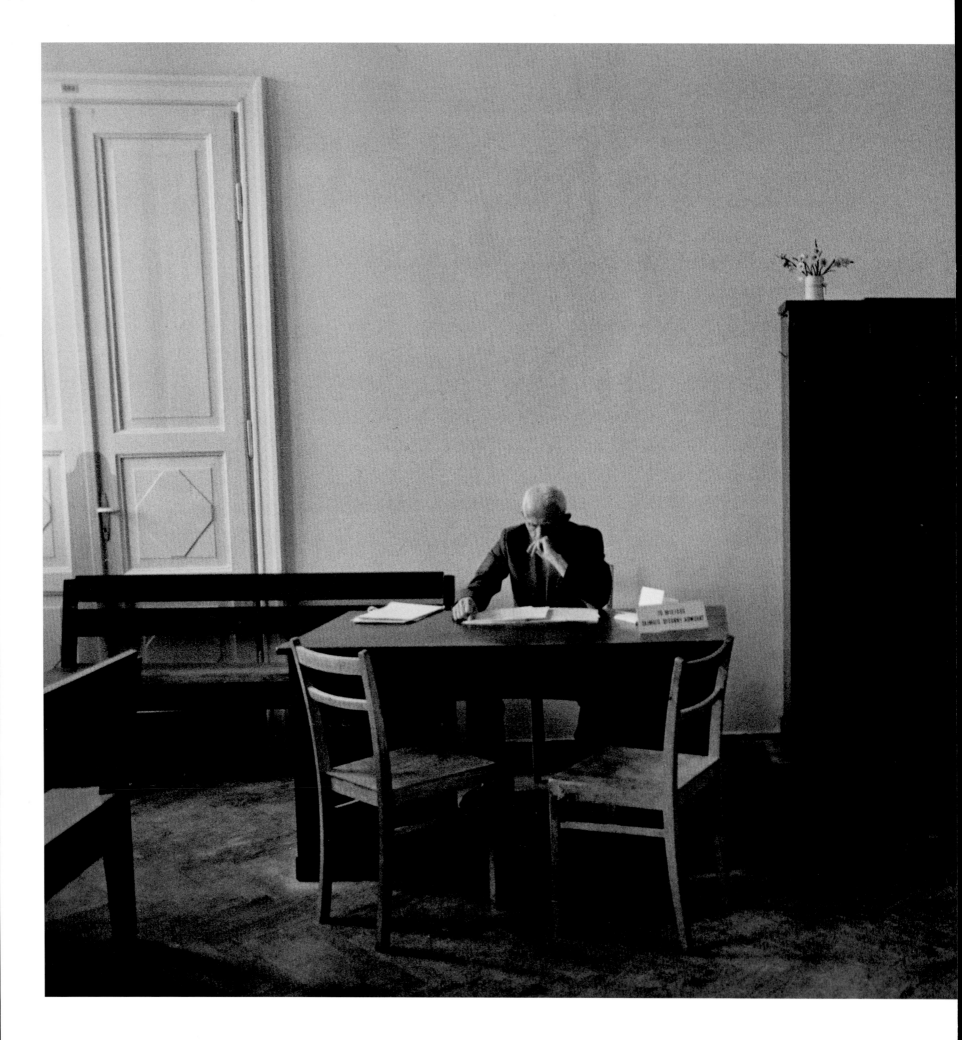

Apartment Czar, Poland 1976

Mafia, Russia 1992

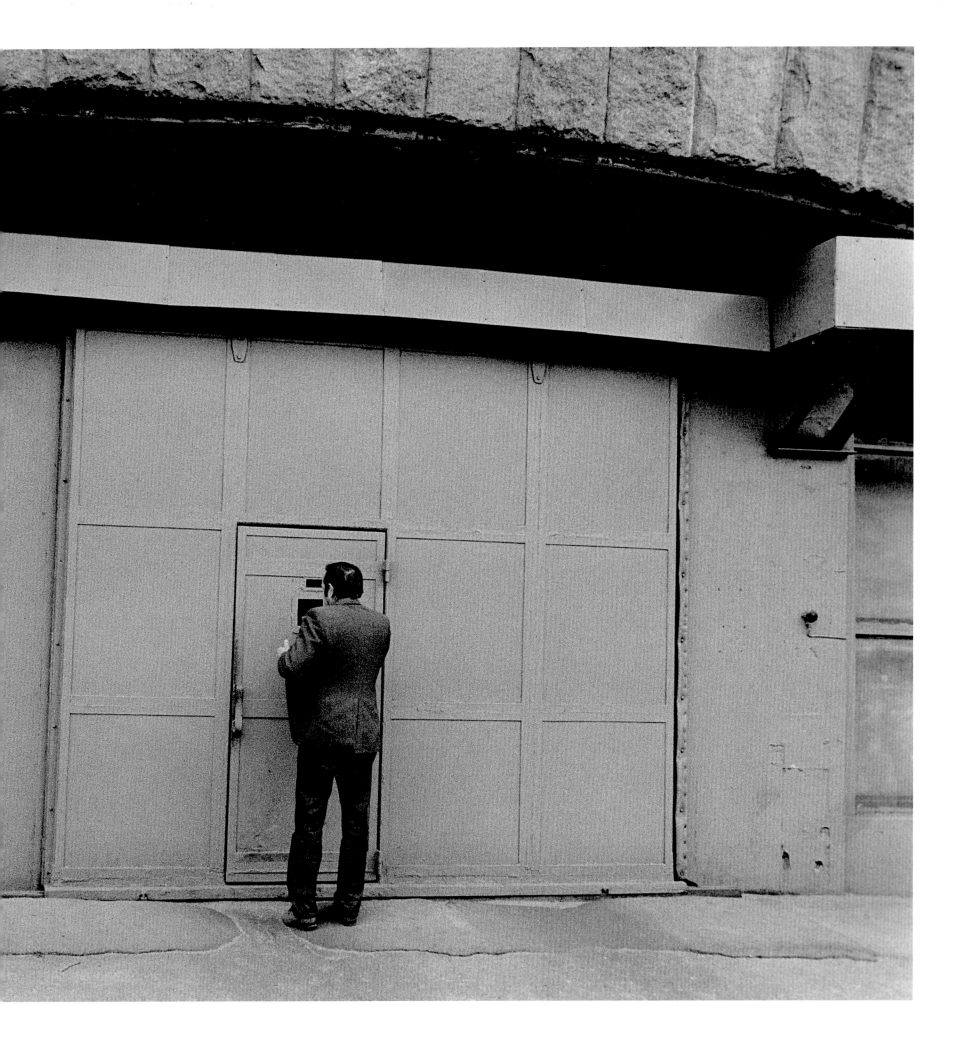

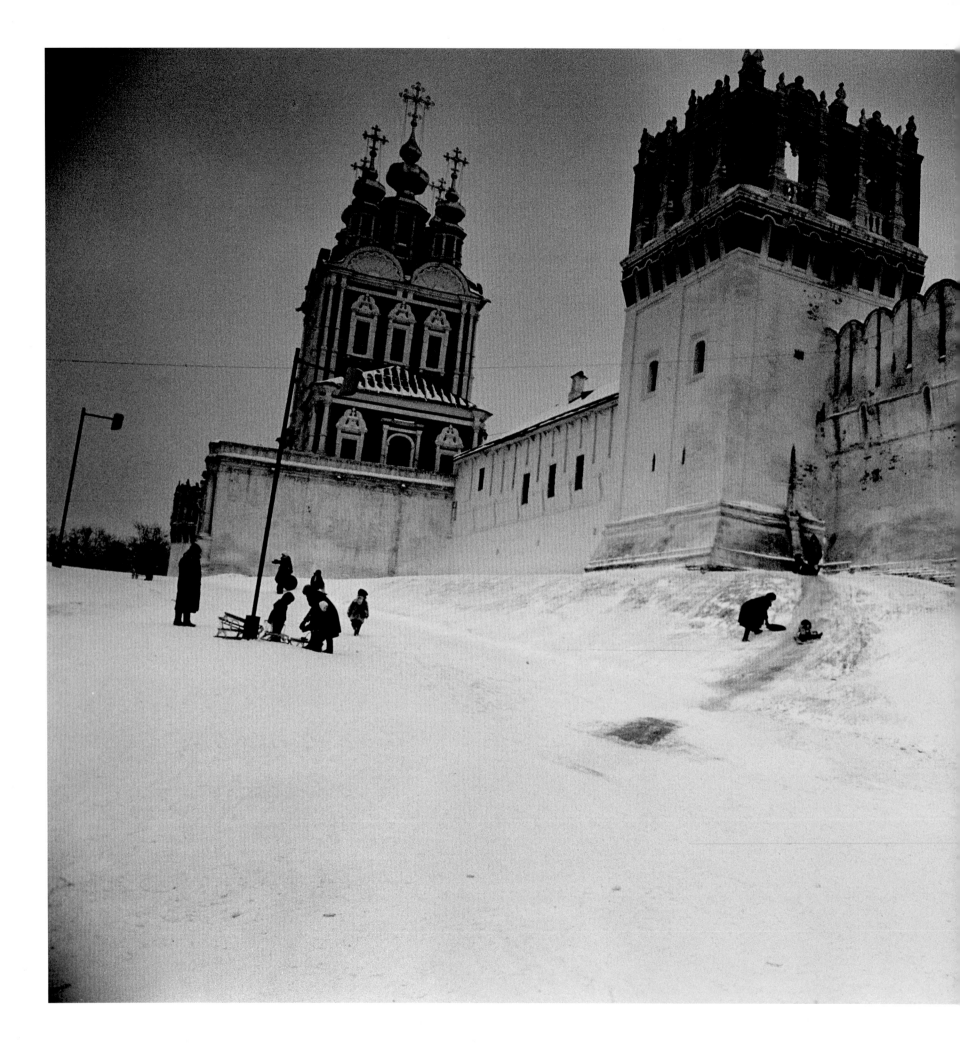

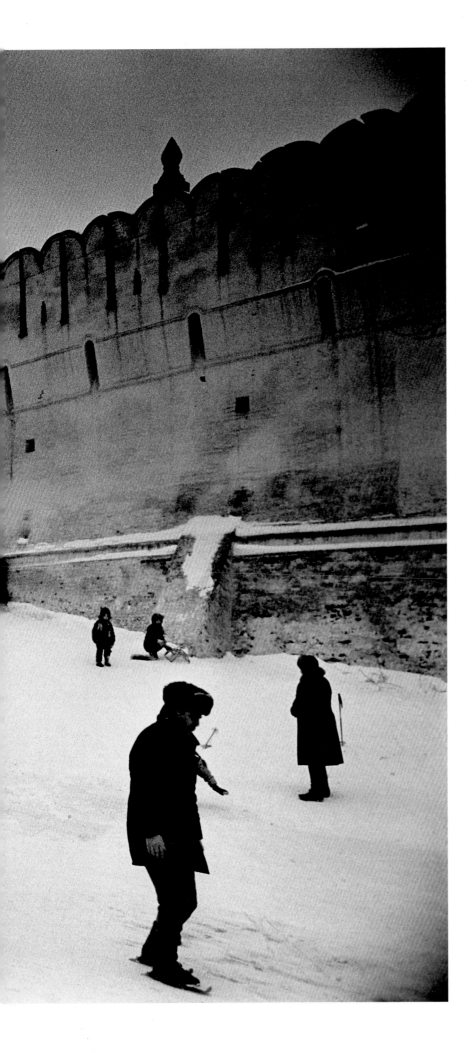

Winter in Moscow, Russia 1990

Frozen Landscape, Poland 1990

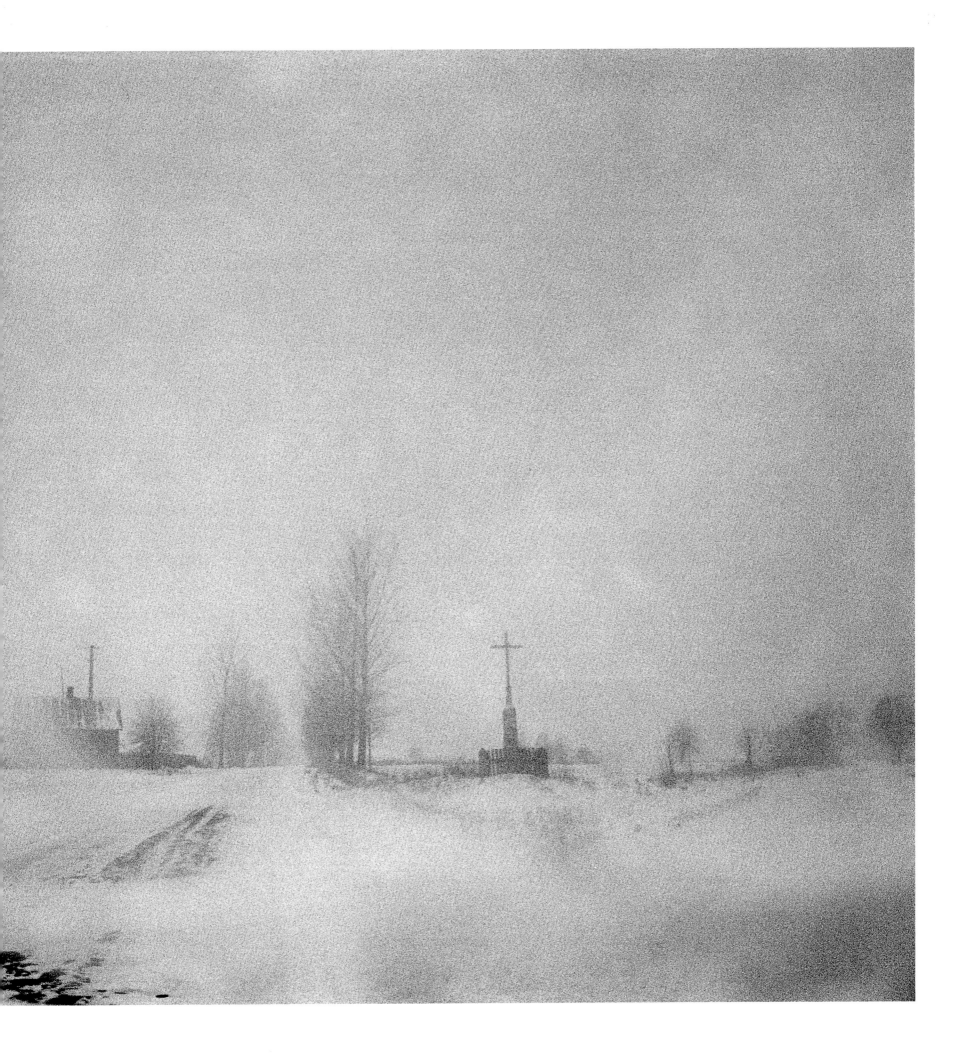

Paranoia, Soviet Union 1989

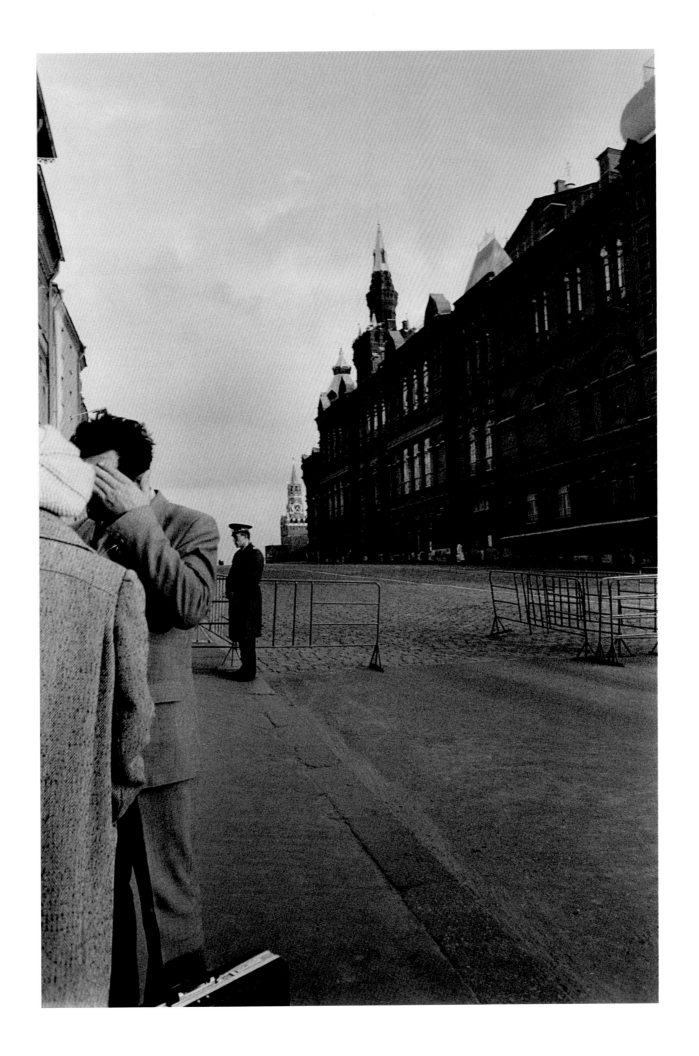

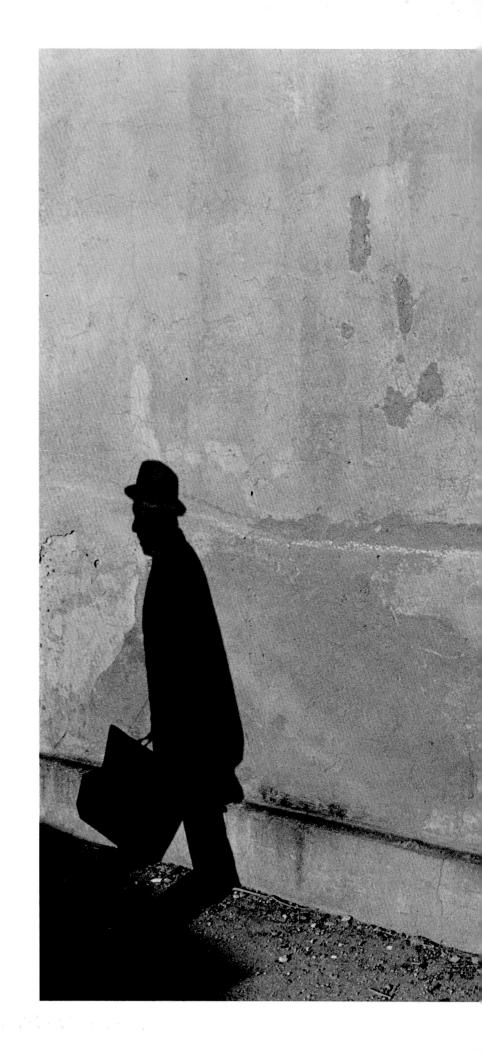

Thieves, Romania 1993

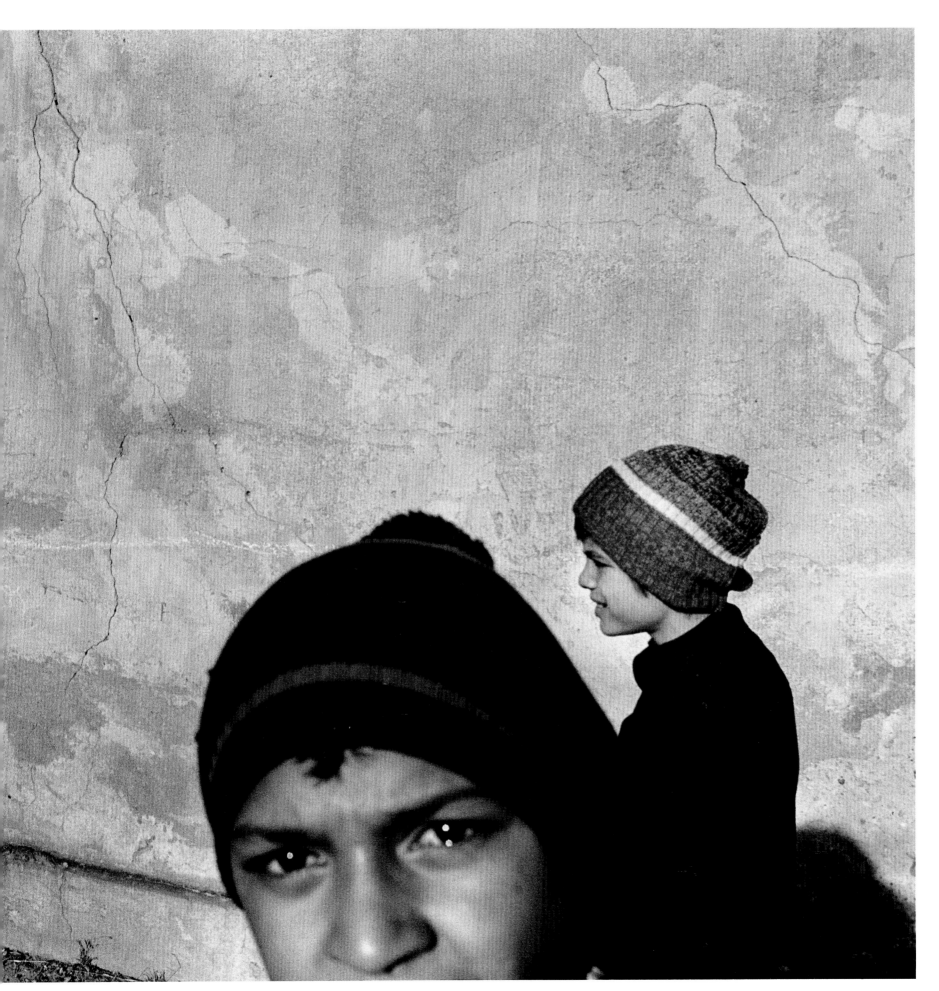

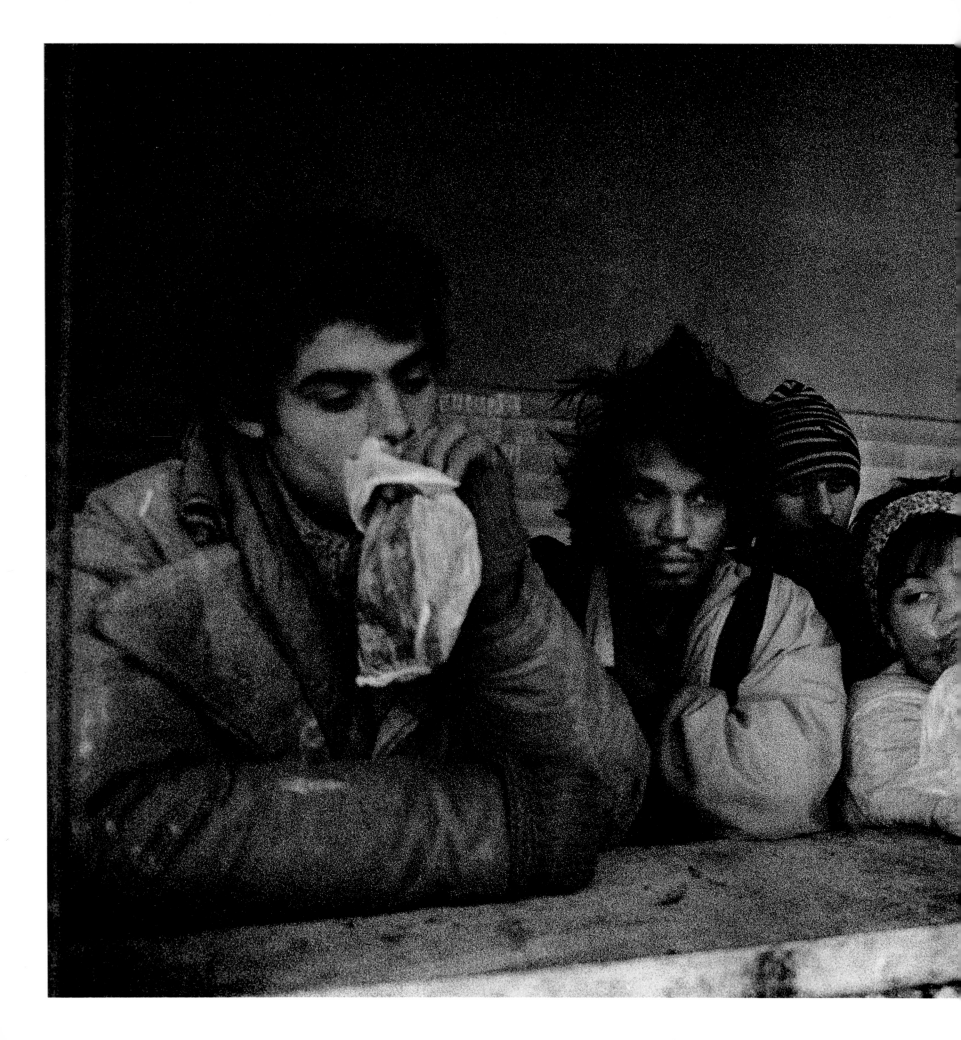

Street Kids Getting High, Romania 1995

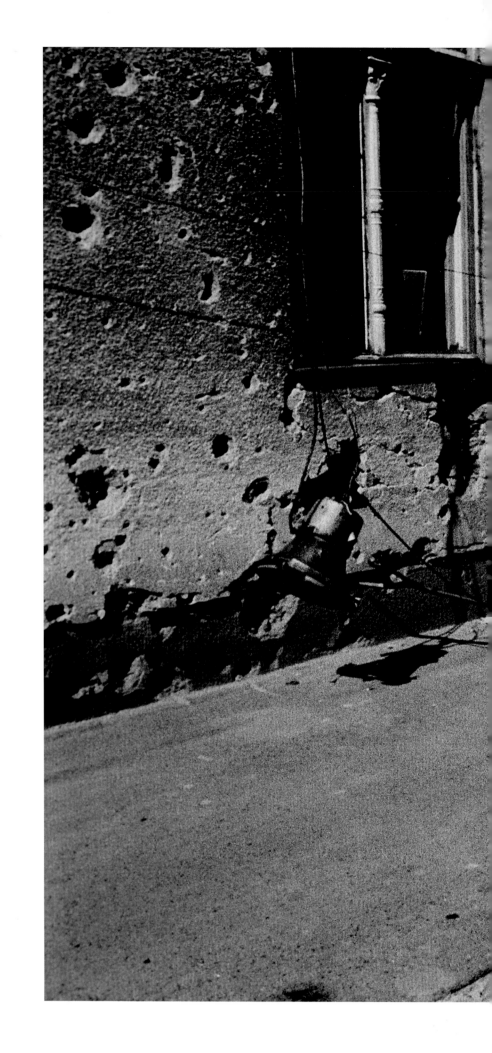

War Wounded, Bosnia 1992

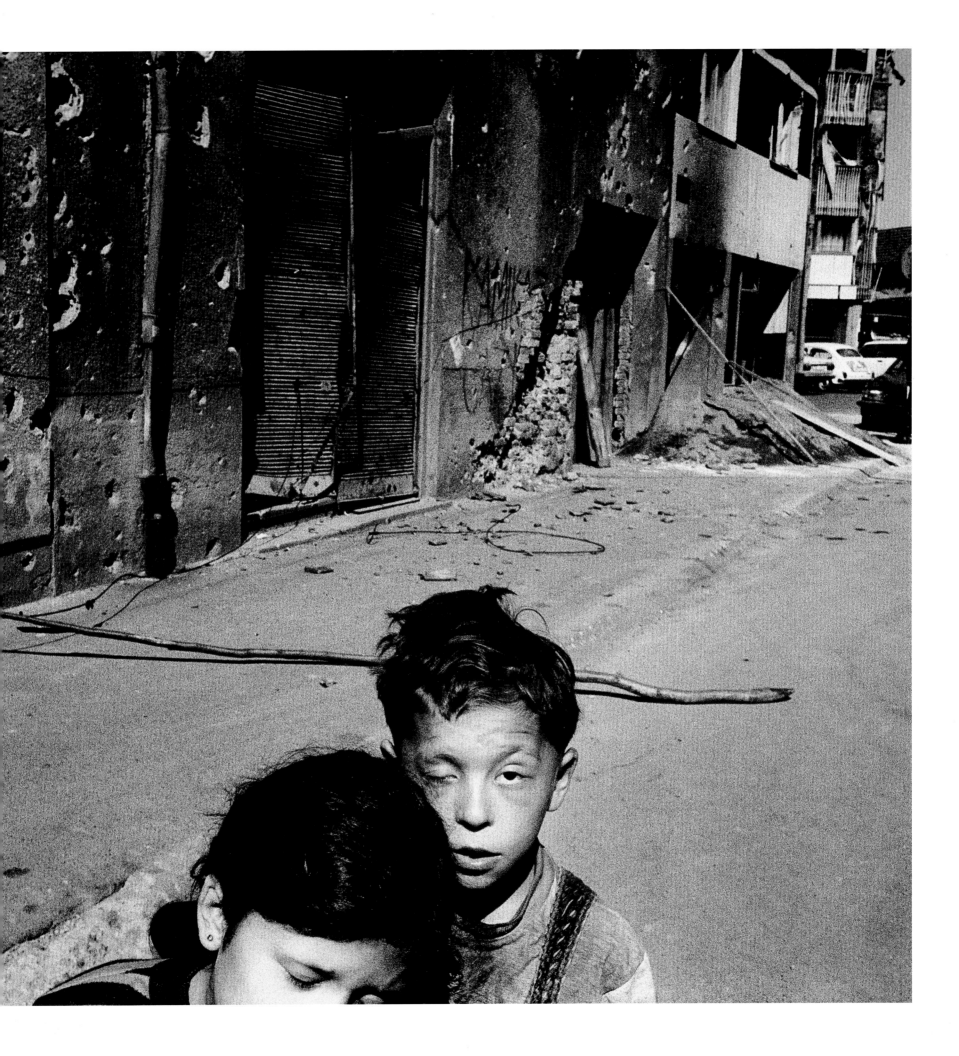

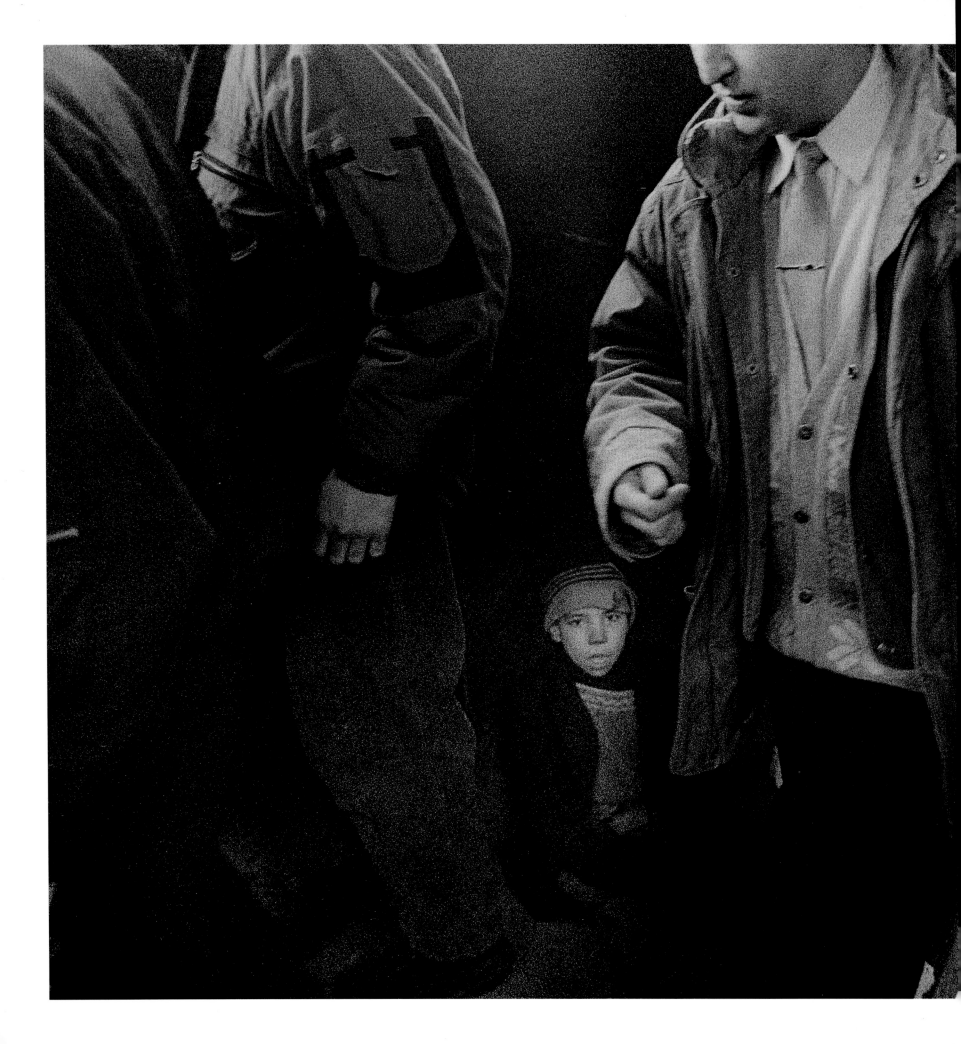

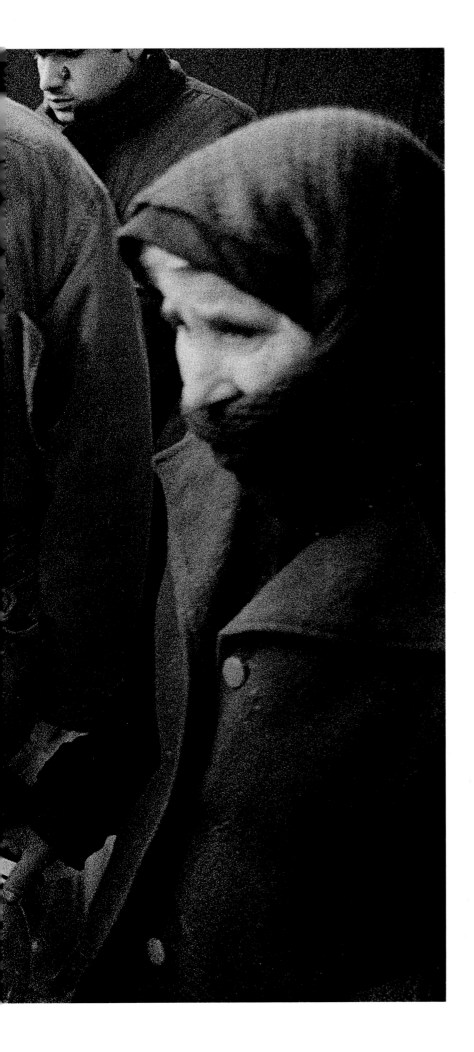

Beggar, Romania 1995

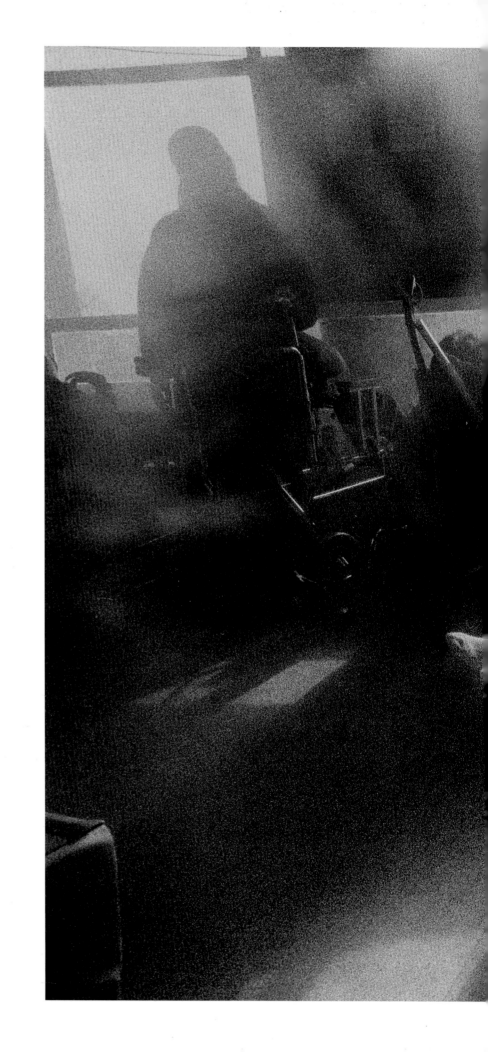

Children's AIDS Hospital, Romania 1995

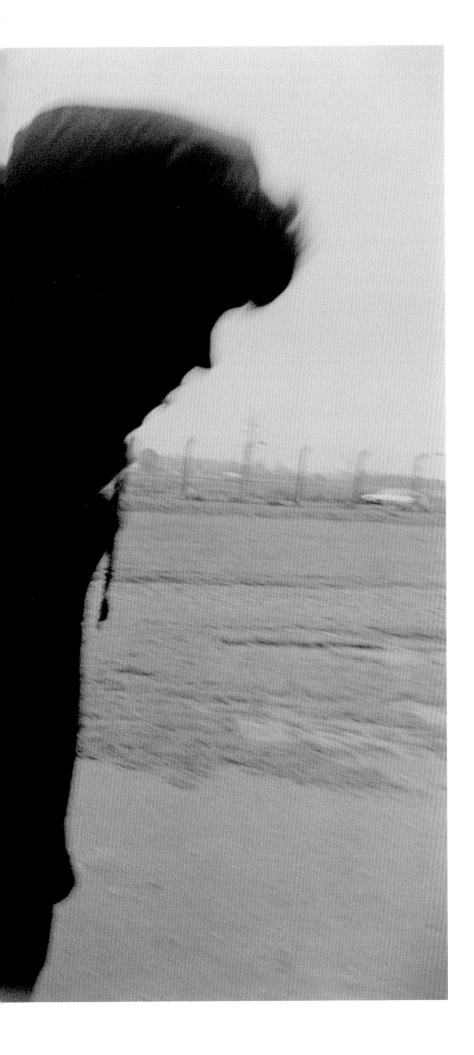

Pilgrimage to Auschwitz, Poland 1992

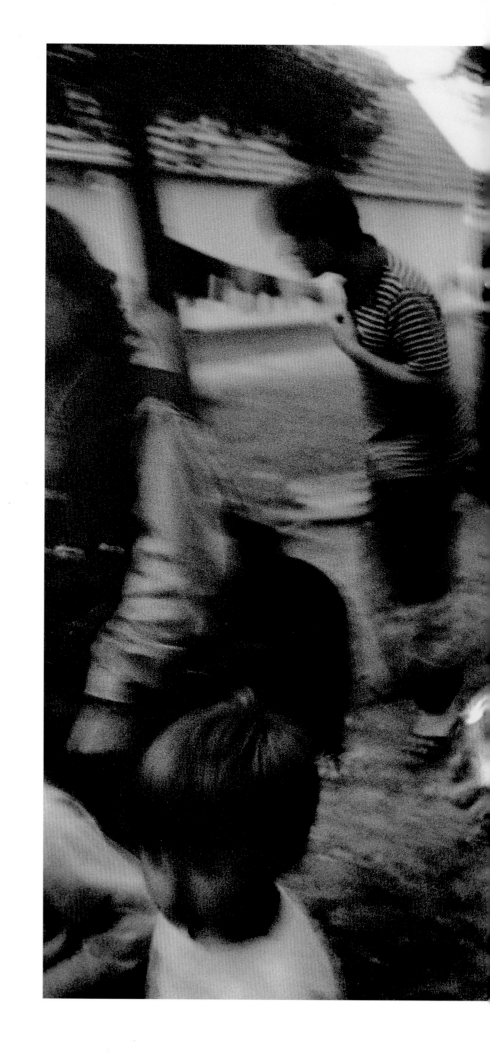

Shell-Shocked Bosnian Refugee, Croatia 1995

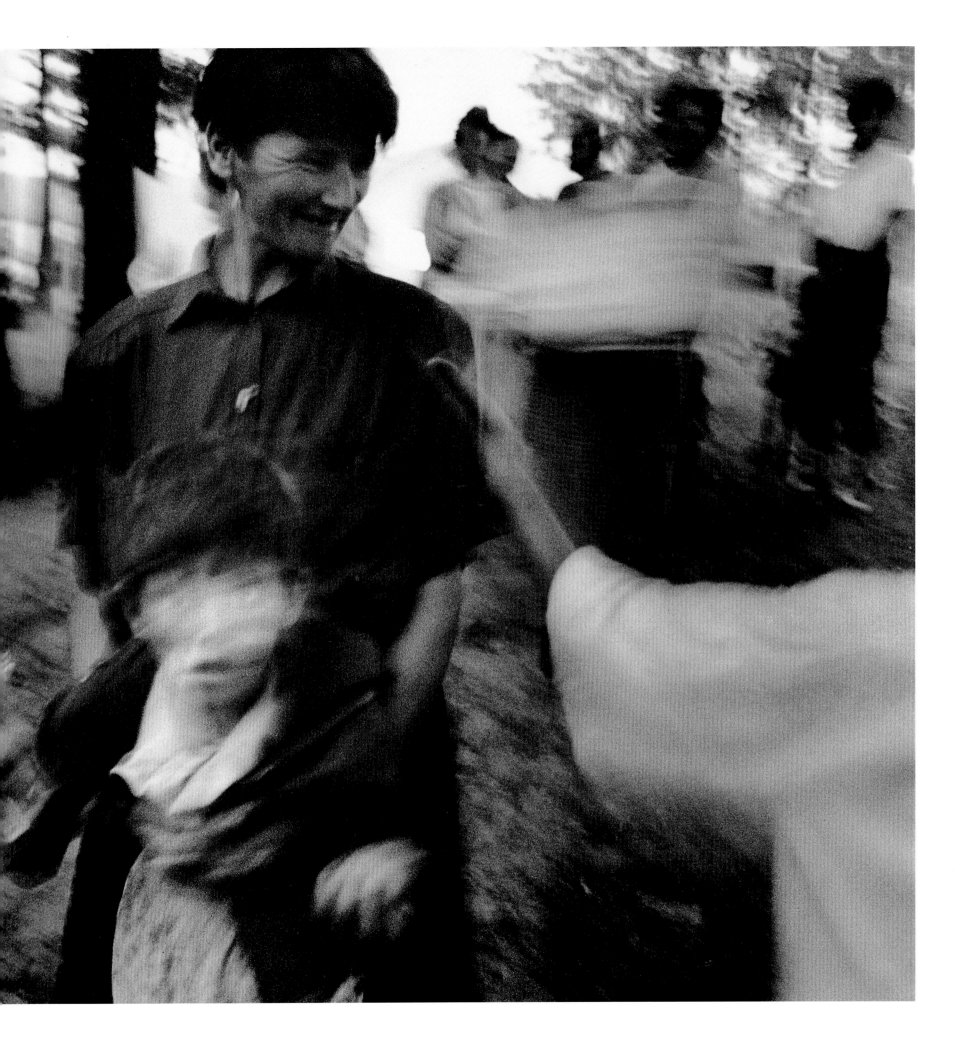

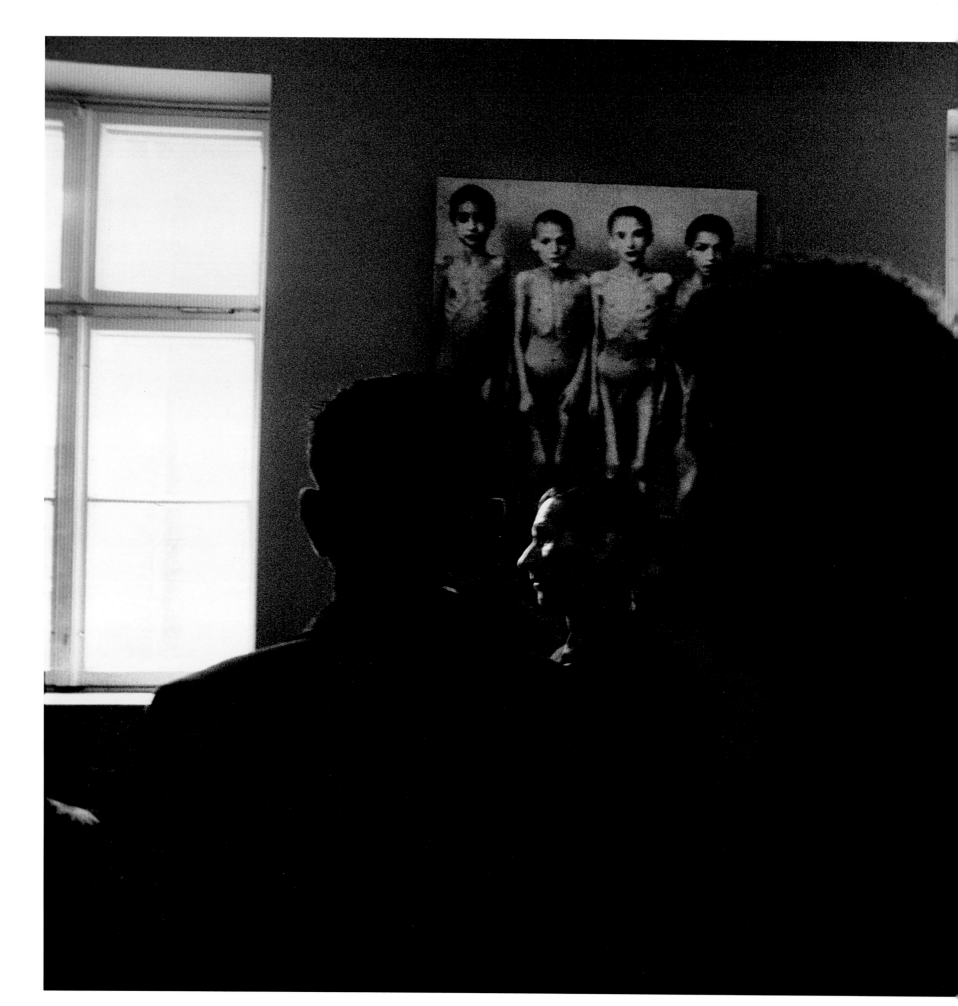

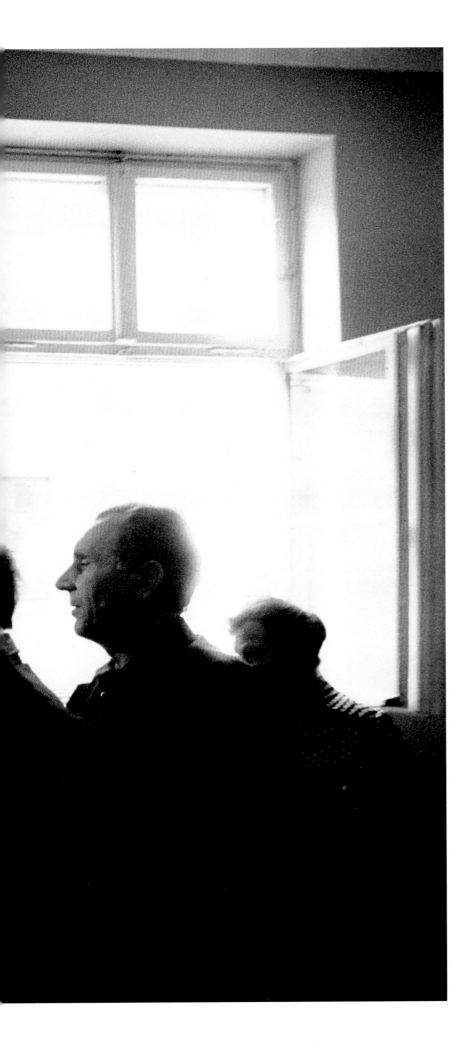

Mengele Kids, Poland 1992

Train to Nowhere, Bosnian Refugee, Croatia 1995

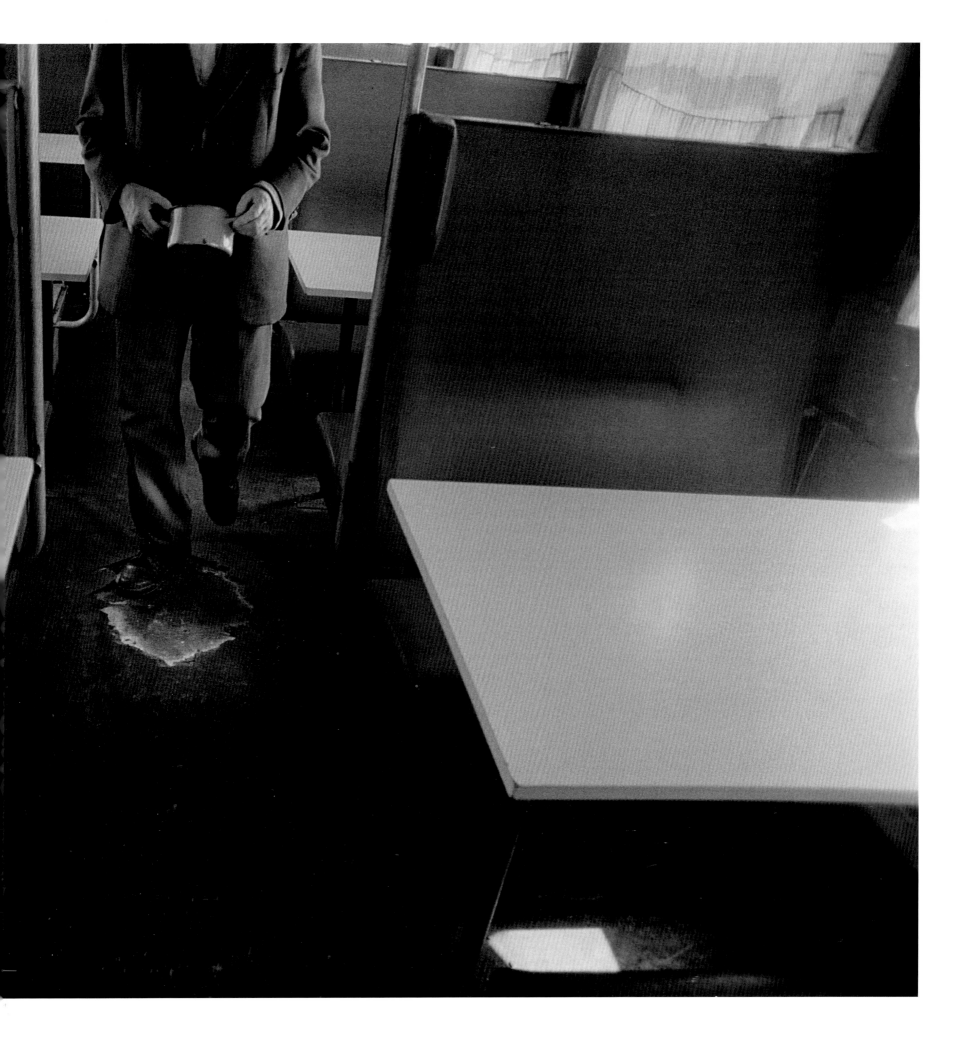

AFTERWORD

I grew up in Czechoslovakia during the fifties. My parents were considered class enemies, and when I was young I spent five years with my parents in the pigstalls in internal exile. After Stalin died, things got better and we moved back to Prague. My father took up his old career—photography. But my parents never really recuperated from the experience and spent the rest of their lives in relative isolation, whispering and not trusting anyone. They whispered when they talked about things that mattered. Once I asked them why and they said "even the walls have ears." So I grew up in an environment of suspicion, paranoia, and fear.

But I didn't want to whisper, so I left Czechoslovakia as soon as I could, in 1967. I crossed the border illegally and made my way to Austria. When I got there I was placed in a refugee camp and treated like swine for a while. Then I wandered around for a few years and ended up in Holland. There I got a new lease on life and began to study photography at the Gerrit Rietveld Art Academy in Amsterdam. After I graduated I married an American woman and moved to California, the land of palm trees and blue skies. But I was very miserable there.

When I first came to America I remember that when I told people I was from Czechoslovakia they said, "Tito! Tito is great." They had no idea where my country was. When I told people that I had escaped from behind the Iron Curtain they visualized it as a solid block of steel and would ask me if I used a torch to cut myself through. It seemed that most people in America were completely ignorant about Eastern Europe in those days.

I started to yearn for the grayness of Eastern Europe, and when I got my American citizenship in 1976 I set out on a journey back. The smells of Eastern Europe, the steam engines, the cabbage, the sweat: it is hard to explain but I had to go. I wanted to go back and make pictures and document life in Eastern Europe and show people here in my adopted homeland what it was. I wanted to show them where I came from, and who I am.

Going back to Eastern Europe and making photographs in the mid-seventies was almost like psychotherapy because I had missed my country so much. I missed my parents, whom I had not seen for many years. During my trips through Poland in the early eighties I explored the medieval quality of eastern Poland, the church, and the mysticism of Eastern Europe. I was not brought up with religion at all, so I had no idea that religion was scorned in most of Eastern Europe. Even though my mother was a closet Catholic, my father did not allow her to tell us about God. In Poland a totally amazing new world of devotion and incredibly strong beliefs opened up in front of me. I saw maybe ten thousand people lying face down in the sign of a cross, covering a whole mountainside. I listened to sermons of the Polish clergy, and they were in complete and open dissent to the Communist rulers. In retrospect I now realize how important religion was to the birth of Solidarity and how it undermined Communist rule in all of Eastern Europe. When Cardinal Karol Wojtyla became the pope it gave the Polish so much courage to fight the Communist rulers. I remember going into Czechoslovakia from Poland during the Solidarity days and being stopped at the border. The Czech government had sent all these high-powered policemen just to stem the flow of dissent coming in from Poland. They took things seriously for a reason. Poland was a big heretic at that time. I photographed the first and last Solidarity conference in Gdansk in 1981, before martial law was declared. I witnessed the struggle of the workers against the Communist rulers. My early days in Poland were very exciting. I felt so liberated and so happy. I was releasing everything that was bottled up inside me through my photography. At the time no one

realized how historic these events were because it was so thrilling. The early eighties in Poland were as exciting as the early nineties in all of Eastern Europe would be.

When I first went to Eastern Europe I could not go to Czechoslovakia. In Poland in the early eighties, I finally found a connection in the Czech embassy, and I managed to bribe someone to give me a visa. Eventually I started traveling farther and farther into Romania and Hungary, always photographing what I felt was a life on the other side, a life that was completely different from what people in the West were used to. There were no billboards, no neon, no advertising of any kind. Cars were a luxury. People's lives in Eastern Europe had not progressed in the same way that they had in the West. Time seemed to have stopped somewhere in the fifties. Visually it was very exciting and I tried to capture the people and their feelings in my photographs. I understood these people so well, I knew every move they would make before they made it. The fear of authority, the fear of uniform, and the paranoia—it was all there.

In the mid-eighties I stopped going to Eastern Europe for a while, and then in 1988 I started going back again. Suddenly there was a new awareness in America about Eastern Europe. With the breakup of the Soviet Union, the Eastern bloc shattered and was put in the spotlight. During the next five years my work in Eastern Europe was supported by numerous magazines and grants. The day of ultimate victory for me was when my shadow fell over the fence at the border between the Czech Republic and Austria at the moment it was being torn down. It was a glorious moment. It had not been easy for me to get permission to be there. I went to a local military outpost and asked if I could photograph the destruction of the Iron Curtain. First they got excited about my foreign license plates. Then they called some general headquarters in Prague and then said, why not. So for two hours I followed a jeep full of soldiers. An officer rode with me. The terrain was very rough, and the entire time the soldiers in the jeep were trying to shake me, but I stuck with them and we finally made it to the border. I was allowed about twenty minutes there. It was

a very important moment for me to see the soldiers working, cutting the barbed wire, rolling it up, and destroying the fence.

Witnessing that kind of liberation was really incredible. Once I was photographing the KGB headquarters in Moscow and the guards charged toward me. I was standing in the middle of the street and I raised my hands in the air and started shouting "Perestroika! Perestroika!" They stopped in their tracks, turned around, and left without a word. Another time was in Prague when Vaclav Havel was elected President—my best New Year's ever. People were so hopeful for new changes, and it was really an incredible climax. Those were the good days in the early nineties.

But it was only five years later that I began photographing the new Eastern European poor. The social upheaval brought a new political elite on the one hand and poverty and disenchantment on the other. Street children, gazari, and extreme poverty are the new reality in Eastern Europe. People were not ready for the ills of the Western world, the capitalist world, that had made their way into Eastern Europe. Today, a lot of people want to bring the Communists back; they are yearning for the old order. It is frightening. I guess that is the cost of transforming a society. It will take some years before it all sorts itself out.

I never thought about doing a book on my work in Eastern Europe. My pictures are the result of pure passion, just going in there and doing my thing. Then in the nineties my photographs had been published so much that people began to say, why don't you do a book. But when I started putting it together I realized that I did not have some vital things. I had to travel to Russia because that is where it all came from, the cold front from Moscow. I had always had a great fear of Russia but finally I went back and worked there. I wanted to show how oppressed the people were by the authorities, by the police. One day I was standing in the Ministry of the Interior because I wanted permission for something, and this legless veteran came in, wheeling himself on a primitive contraption. The guard from the ministry kicked him out. I was right there and I knew that picture would tell the story.

In 1996 I did a story on the anniversary of Chernobyl. It is a very dangerous place and yet it is so beautiful. People have moved back into the forbidden zone. They do not believe that they will die from the radioactivity; they think that if they cannot see it, it cannot kill them. They also believe that if they drink vodka, it will cure them.

I also photographed the gazari, the gasoline people. In Ploesti there is a huge refinery that has been spilling oil into the ground for at least fifty years. It has polluted an area the size of Cyprus but underground (as my friend Jan Novak says). If you dig a hole ten feet deep you find diesel fuel. The gazari dig holes and sell the diesel to people. Under Ceausescu the gazari did their digging and selling under cover, at night. But now they have made a business out of it. They live under these terrible conditions in an unbelievably dangerous environment. Sometimes they burn to death, sometimes they inhale the stuff and collapse, and sometimes the holes cave in and they die. But if they do not die from some mishap they eventually die from living in the diesel.

I did a photo essay called "Eastern Europe, The Polluted Lands." I photographed the destruction of the environment and the ravaged landscape in Bitterfeld, Katowice, the Polish basin, and all through Eastern Europe. I ended up in Romania in a valley called Copsa Mica; a rubber factory had been polluting it for at least forty years. Everything was black, including the people. When it rained, the rain was black too. The people were sick; you could see the kids had nervous twitches. It was a cancerous, creepy place to be. It was like Armageddon.

It was in Copsa Mica that I found the gardener who is on the cover of this book. I came to this man through a field of sheep. Everything was completely black, the earth was black, and this man was digging in the ground. He was trying to make something out of it. It is amazing that this man was trying to grow something in this absolutely poisonous environment. I think people living in these conditions subconsciously go through the motions of a normal life to try to keep their sanity.

Thanks to my early traveling companions
Jill Hartley, Janek Hausbrandt, Jan Kuzelka, and Michal Vápenik (my son)

Thanks to the people who knowingly and unknowingly supported this project:
David Armario, Bill Black, Roger Black, Richard Body, Robin Bowman,
Joe Brooks, Alice George, Abie Heyman, Charlie Holland, Peter Howe,
Kathleen Klech, Amy Koblenzer, Laurie Kratochvil, David Marcus,
Jim Megargee, Trip Mikich, Alison Morley, Jan Novak, Greg Pond,
Kathy Ryan, Marcel Saba, Bruce Stutz, Lisa Thackaberry,
Kerry Tremain, and Vincent Winter

This project has been completed with the help of
Ernst Haas Working Grant, Dorothea Lang Prize from Duke University,
Leica International Fund for Photography, and *Mother Jones*

Special thanks to
Paola Gribaudo, Gianfranco Monacelli, Steve Sears, and Daniel Skira